Salvadoran:
CÉSAR A. MARTÍNEZ

CÉSAR A. MARTÍNEZ
A RETROSPECTIVE

JACINTO QUIRARTE
CAREY CLEMENTS ROTE

TheMcNay

THE MARION KOOGLER MCNAY ART MUSEUM

Lead funding for this exhibition and catalogue has been provided by Barbara and Harold Wood.

CÉSAR A. MARTÍNEZ
A RETROSPECTIVE
An exhibition presented at
The Marion Koogler McNay Art Museum
San Antonio, Texas
July 13 - September 12, 1999

On the cover: *El Güero* (Catalogue 12)
Collection of Cheech Marin, Los Angeles

TABLE OF CONTENTS

FOREWORD

César Martínez's work has fascinated me since the early 1970s when I first saw his prints, drawings and paintings. His highly original interpretation of well-known motifs used by Chicano artists – pre-Columbian stamp designs, Our Lady of Guadalupe and barrio-types, known as *Pachucos* (zoot suiters) or *Batos* (barrio youth) – attracted me to his work. His sense of humor and ability to capture the essence of his subject – portrayals of barrio types in particular – stood out from all the others I was studying and writing about at the time. He consistently came up with original visual solutions to questions of identity and the nature of Chicano art, history and culture. His work showed that he was not simply transcribing motifs that by then had been identified with Chicano art. He consciously resisted using motifs, such as pyramids and Our Lady of Guadalupe, because they carried too many non-art points of reference. Nonetheless, he found it necessary to comment on the tendency to use such motifs in his 1975 work, titled *Mona Lupe: The Epitome of Chicano Art*. In doing so, he followed other artists who used art to comment on the art of their time as in the case of Marcel Duchamp's altered readymade, a doctored reproduction of Leonardo's *Mona Lisa*. He eventually used pyramids as well as other Mexican and Chicano motifs in his *Mestizo Series* to focus on questions of identity.

Another characteristic of César's work is his use of symmetrically balanced compositions, particularly in his *Pachuco* or *Bato Series*, along with others divided into three different zones, as in his *Mestizo Series*. This demonstrates a willingness to use the most direct visual route to his audience rather than through overly elaborate formulations. He has often indicated in conversation and in more formal interviews that he has always been attracted to frontality and centrality in his compositions. During a lengthy interview conducted last year, I pointed out to him that some of his solutions are similar to those found in some pre-Columbian sculptures.[1] He was quite surprised because he was not aware of these examples. Although he is familiar with other bodies of work in which tripartite compositions were routinely used, such as Mexican *ex-voto* paintings,[2] he has not consciously used them as a point of reference for his work. His solutions are the result of his own analyses of the visual and thematic problems he sets out for his work rather than a conscious effort to use these traditional sources.

César's masterful use of color, composition and strict frontality, is particularly evident in his *Pachuco* or *Bato Series* paintings and prints. He acknowledges the

modern sources that have influenced these works, such as 19th century photographs in which the sitter stares directly at the camera, Richard Avedon's photographs of well-known personalities, and the imaginary spatial envelopes around Giacometti's sculptures. The latter are particularly important in his formulation of the space around his figures, additionally defined by a horizontal band along the top of the visual field.

Ultimately, César's work reaches a broad audience in spite of its thematic specificity because it deals with issues that touch all of us in a very direct and honest way. It draws our attention because of the familiarity of types (the *Pachuco* or *Bato Series*), religious icons (Our Lady of Guadalupe), Chicano identity (*Mestizo Series*) and the land (*South Texas Series*). These motifs and themes, and the experiences from which they stem, transcend ethnicity and nationality. They become an integral part of works of art that engage us by their artistic quality and themes which deal with the human condition, identity, culture, history and our relationship with the environment.

It is for these and many more reasons that I am particularly pleased to be part of the celebration of César's work that this retrospective exhibition represents.

Dr. Jacinto Quirarte
Professor Emeritus, History of Art
The University of Texas at San Antonio

1. A tripartite composition is found in one of César's earliest woodcuts, titled *Liberación* (pl. 45). Without realizing it, he arrived at a formal solution that is also found in a number of little-known pre-Columbian sculptures dating from the 8th century A.D. Most of these sculptures found at the site of Naranjo, Mexico, invariably include a deceased captive in the lower register, a victorious warrior/ruler standing on the captive in the middle one, and an ancestor or explanatory text in the upper one.

2. The three zones of César's works in the *South Texas Series*, also echo Mexican *ex-voto* paintings, almost always divided into three registers: the text in the first, the calamitous event in the second and the venerated religious image in the third.

INTRODUCTION AND ACKNOWLEDGEMENTS

César Martínez is an artist with a remarkable ability to create images that last in our visual memory long after we have seen them. In part, this is a result of his talent for selection, an ability to derive images from popular culture and from the history of art that have resonance. But it is also a result of his power to create images of graphic clarity.

Although rooted in tradition and in the world around us, his images are distinctively his own, and have an iconic character whether they be his *Bato* portraits, his South Texas landscapes, or his multi-part historical constructions of the *Mestizo Series*. Before they actually represent anything, they are first and foremost themselves: Martínez objects.

César Martínez stands out for his ability to work in a number of different modes simultaneously and in a wide range of media, including painting, assemblage and collage, drawings in charcoal and pastel, watercolor, and a variety of print techniques, including monotypes, lithographs, and woodcuts. Technically adept, he chooses what will help him achieve his expressive goal of creating something new.

It has been a pleasure and an honor to organize this exhibition and collaborate on selecting the works to be included. On behalf of the McNay Art Museum and our entire exhibition team, I offer this retrospective in the belief that it will be a most enjoyable revelation for our public.

Five years ago, when McNay trustee Harold Wood and his wife Barbara agreed to be lead sponsors for a series of five retrospective exhibitions devoted to artists who have made a major contribution to the visual arts of San Antonio and South Texas, full retrospectives of living artists in our region were seldom if ever presented in San Antonio. The primary reason for this omission was the lack of human and financial resources to make such projects possible. The organization of retrospectives, and the research that must go into the selection of the objects and the publication of a catalogue are highly labor-intensive, and the production expenses are substantial. However with the Woods' concurrence that this was an important role for the McNay to take on, and thanks to their continued, generous support and that of our co-sponsors, we have now, with this retrospective, accomplished four major exhibitions and publications. For the Martínez retrospective, I am particularly grateful for the enthusiastic support of Henry R. Muñoz III with our additional fundraising efforts.

From the beginning, César Martínez has been among the artists we hoped to include in our series, and I am delighted that we could assemble the curatorial team to bring this exhibition to fruition in 1999. I am grateful to guest curator Professor Carey Rote of Texas A&M University at Corpus Christi who has helped me select the works of art to be exhibited and has written the enlightening main catalogue essay, and to Professor Jacinto Quirarte of the University of Texas at San Antonio, a pioneer scholar of Chicano art and artists, who has written an eloquent foreword in addition to providing a very helpful glossary of Spanish language terms.

Allison Hays Lane, director of the Artist's Gallery in San Antonio, deserves special thanks for her tireless

work in assisting with the organization of the exhibition and especially with the publication of the catalogue. From helping to assemble the photographic records to coordinating the work of the many catalogue contributors and serving as editorial organizer, she has been a great help in keeping the project on schedule. I am grateful to Harold Wood for lending her services to the McNay once again.

Many others have contributed to the production of this catalogue. Marcia Goren Weser has served very ably as copy editor. Carmen Viramontes has reviewed all Spanish vocabulary. Michael Jay Smith has produced the vast majority of the photographs for the catalogue to his usual high standards. Many thanks to Rosemary Flores and Erminia Irlas, of Federal Court Reporters, for generously donating services. Chuck Maurer and Jonathan Marcus of Command P, with the assistance of DeLinda Stephens and Roslyn Walker, have given their customary care to the design and production of the catalogue. And, Mr. Maurer has made a generous contribution of his own and his staff's time. I am also very grateful to Carrie Phillips of Clampitt Paper Company and Blakeley Anderson of Zanders USA for working with Command P and the McNay to produce such a beautiful catalogue.

Nearly every member of the McNay's staff has contributed to the realization of this project. Among those who deserve special thanks is Heather Lammers, collections manager, for her skillful handling of the arrangements for photography, loans, and shipping. I would also like to thank Rose Glennon, curator of education, for her imaginative educational programming to accompany the exhibition, and Edward Hepner, head preparator, and Patric Cormier, assistant preparator, for their careful work on the installation. Lastly, my thanks to Melissa Lara, assistant to the director, for her help with numerous details related to the exhibition.

This retrospective would not have been possible without the generous cooperation of the many lenders who have given up their works of art to the McNay for the entire summer. My sincere thanks to all of them and especially to Joe Diaz for his enthusiasm for the exhibition and his generosity in lending nearly all of his fine collection of César Martínez's work to the Museum.

Finally, my heartfelt thanks to César Martínez for creating such a challenging body of work, and for being so generous with his time and with loans from his personal collection. It has been a delight to work with him.

Dr. William J. Chiego
Director and Organizing Curator
The McNay Art Museum

CÉSAR A. MARTÍNEZ: A DUAL HERITAGE

In his Realist Manifesto of 1855, Gustave Courbet proclaimed that his goal was "…to be in a position to translate the customs, the ideas, the appearance of my epoch, according to my own estimation…in short, to create a living art."[1] In many ways, César Augusto Martínez could be considered to be the Courbet of our era for the Hispanic culture in South Texas. In his mature works, he presents the figures and environment of South Texas and Northern Mexico. It is a place where European and native influences converge to create a unique culture that is not entirely European and not entirely New World in character, but an amalgamation of both. Martínez's work deals with the dualities that are a part of this heritage.

Martínez is one of the most important artists in the contemporary Chicano Art movement. He has been a leading member of the movement since the early 1970s. Martínez, a South Texas native, was raised in Laredo. He also frequently visited his familial ranch in the state of Nuevo León in Northern Mexico. For him, crossing back and forth across the border was a natural experience. He identified both lands as his own, in a manner that many Hispanics have had the pleasure of enjoying.

Martínez had begun to develop his own unique style in a series of woodcuts from the 1970s. These woodcuts reveal Martínez's desire to immerse himself in the expression of his cultural heritage. Representative of this time period is *Dando Vida* of 1975 (fig. 1). In this image, Martínez presents a cosmological view typical of pre-Columbian thinking. At the base of the cosmology, buried inside the earth and metaphorically in the "Underworld," are human skeletal remains crouched in a fetal position. Looking upward, the skeleton appears to be shrinking in horror as the roots of a maguey reach into his space to surround him. *Dando Vida* means "giving life," which is symbolized by the maguey taking life from the skeleton. The plant is superimposed upon a pyramidal shape. Light from the sun streams down in a brilliant sheet of white, adding to the emphatic geometry of the symmetrical composition. Off to the right is a moon, accompanied by stars, in a darkened sky.

The juxtaposition of the sun and the moon is derived from pre-Columbian mythology that places a great emphasis on the natural oppositions of the world.[2] The struggle between the sun and the moon is also portrayed in *Vacilando* (fig. 10) and *Tranquilidad del Vato Quemado* (fig. 9).

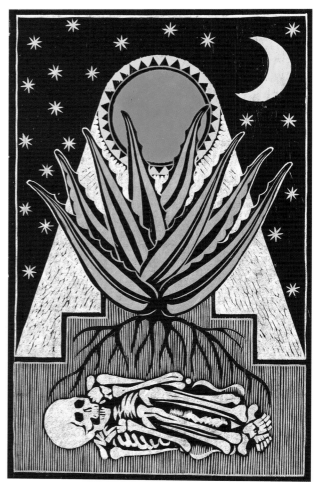

Figure 1
Dando Vida (cat. 71)

Dating from this same time are two representations of Don Pedrito Jaramillo. In these woodcuts, Martínez uses some of the same compositional devices that he used in *Dando Vida*. Both images present Don Pedrito in a

symmetrical arrangement. He assumes the same frontality that will appear in Martínez's later images of the *batos*, *pachucos* and *rucas*. In the image that represents Don Pedrito in bust format, the moon and the stars appear below him and the rays of the sun above him, echoing the duality of sun and moon utilized in *Dando Vida*.

Don Pedrito Jaramillo (1829-1907) was a folk healer in Falfurrias, Texas, who is well known among Hispanics in South Texas and Northern Mexico. He is celebrated, along with "El Niño" Fidencio of Espinazo, Mexico, as one of the great faith healers. Don Pedrito was born in Guadalajara, Mexico. Once, while riding his horse, he suffered a serious blow to his nose that permanently deformed it. He cured himself through the application of mud. Then God appeared to him in a dream and told him that he had received the gift of healing.

In 1881, he moved to the small ranch of *Los Olmos* (The Elms) near Falfurrias where he began to treat others with a variety of cures.[3] Martínez represents him again later in *El Señor de los Milagros* (pl. 25) of 1991 in a large triptych format. In the center is the photographic image of Don Pedrito surrounded by the sun placed as a glowing orange orb rising against a starry firmament. Don Pedrito's feet overlap the frame of the photograph to land squarely on the South Texas earth. He is magically suspended before the viewer, a powerful force for healing. In the two side wings of the triptych are represented clusters of glowing devotional candles.

Another series that Martínez worked on briefly during the formative phase of the *Bato Series* was based upon representations of serapes. These images began as abstract, hard-edged bands of color. They eventually evolved into a combination of abstracted forms with more realistic imagery, as can be seen in *Tauromaquia* (pl. 21) and *Flores Para Los Muertos* (fig. 2). *Tauromaquia* relates to the bullfight with the representation of the bullring, the banderilla of the banderilleros and red carnations at the bottom (as thrown into the ring by appreciative spectators). The bullfight theme will reappear in later images.

In *Flores Para Los Muertos*, Martínez represents an important Hispanic celebration – The Day of the Dead – that is celebrated on November 1 and 2. In this annual event, Hispanics make pilgrimages to cemeteries to visit the graves of their deceased relatives. They offer flowers, food, and drink at the graves. In homes, altars are set up where similar offerings are left, along with letters to and photographs of the deceased. In this painting, grave markers in silhouette are placed above the serape. The serape itself is adorned with three skulls – images of the dead. Below the serape, arranged in a decorative pattern (in a manner similar to the roses in *Tauromaquia*), are the flowers for the dead. The organized "scattering" of the flowers enhances the symmetrical and orderly arrangement of forms throughout the image. The strong frontal composition relates to the early woodcuts and to the subsequent series of *Batos*.

Figure 2
Flores Para los Muertos (cat. 30)

THE BATO SERIES

In 1978-80, Martínez began to work on images of street characters from the Chicano community, remembered from his youth. These figures are an important theme for

Martínez – one that he continues to visit frequently in his art. The *pachucos*, *batos* and *rucas* of the *barrios* are not strictly "portraits," but recollections of types of people that Martínez knew.[4] They often represent types from the 1940s and 1950s, wearing clothing and hairdos that may no longer be stylish and that date them very specifically.

Some of the earliest images in this series establish the format that will be repeated over and over again – the bust or waist-length portrait against a large painterly background. *Mujer in 1950s Pose* (pl. 39) and *Bato Con Sunglasses* (fig. 3) are good examples of some of these early works. *Mujer in 1950s Pose* is a sympathetic and rather glamorous portrayal of a young Hispanic woman from the 1950s.

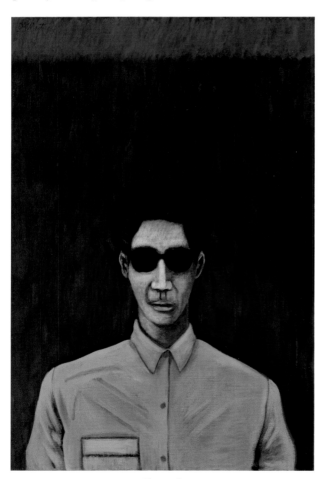

Figure 3
Bato con Sunglasses (cat. 1)

Bato Con Sunglasses is painted against a larger background field and seems slightly more removed from the viewer. The *bato* with sunglasses looks like a tough or cool dude, staring (one assumes) in our direction. He is painted in a blue shirt and placed against a blue background, except for a narrow band of contrasting blue at the very top that helps define the terminus of the painting. It serves in the same manner as a lintel over a door or as a cornice on a building.

La Parot (pl. 2) reflects an earlier era as it represents a *bato* combing back his hair with La Parot Hi-Life Hair Dressing. The emblem of *La Parot* is placed above the *bato's* head in a slick format that has the appearance of an advertisement and reflects a strong influence from the Pop Art movement. The figure in *La Parot* is different from those of other *batos* because of his posture and profile view. Most of the other *batos* are placed frontally in bust-length portraits. There are only a few other exceptions, such as *El Enano White* (pl. 6) and *1940s Style: UFO and Pachuco* (fig. 11).

Martínez cites several different sources as the inspiration for his *Bato Series*. The first source is, of course, the people from his own Chicano culture. He has collected these images from high school yearbooks, the media, obituaries and other sources. The second influence is Richard Avedon, a photographer who worked in the tradition of Diane Arbus, in presenting direct frontal images of common people. Avedon places a person against a vast, empty expanse, heightening our awareness of the individual's unique characteristics, and emphasizing the person's loneliness in the world.

Alberto Giacometti is another source for the loneliness that Martínez wishes to express. Giacometti created extremely thin sculpted figures built up with a heavy textural surface. Martínez translates this effect into paint by using a rich background texture. His backgrounds are also influenced by his early interest in Color Field Painting and Abstract Expressionism. Martínez justifiably feels that his mature figurative works are informed by his experience with abstraction. Such an influence can

be clearly seen in *Bato con High School Jacket* (pl. 8) and *Hombre with a Very Reasonable Dream* (fig. 16). In both of these paintings, the figures are clearly and firmly modeled, but the backgrounds they are painted against are energized by variations of color and vibrant brushstrokes. In *Hombre with a Very Reasonable Dream*, the background is particularly alive with movement, perhaps reflecting the energy of the *hombre*'s mind.

Each portrait represents a characteristic personality. Some are humorous; others are more poignant portrayals. As a group, they provide a variety of street types that society at large may prefer to ignore. Yet, here they are in all their glory – the common man elevated to the level of high art.[5]

Martínez's characters allow the viewer to instantly identify with their basic and very human characteristics. For example, *La Chata* (pl. 20) dons a beautiful dress and has her hair teased in a glorious cascade. Busty and rather coarse, she looks ready to find her man. *La Fulana (The Other Woman)* (pl. 7) is a different story. As the other woman in a relationship with a married man, she is scoffed at by members of her community. Sultry and sexy, she appears unconcerned with the rumors that surround her.

Some of the *batos* look "cool" and in control, like the man in the pink pants in *El Pantalón Rosa* (pl. 3). He is ready for anything, as he stands with his hands in his pockets and sunglasses covering his eyes. Other *batos*, like *Screaming Bato* (fig. 4), appear to be out of control, perhaps in an allusion to Edward Munch's *The Scream*. *Screaming Bato* looks menacing, his face contorted and harsh colors accenting his nose and cheeks.

Wrong-Headed Hombre (pl. 14) and *Hombre Que le Gustan las Mujeres* (pl. 5) represent tough guys with tattoos. The *Wrong-Headed Hombre* has two heads to show that he is of two minds. On the one hand (or arm), his heart is with the nice girl whom he longs to marry. The beautiful girl on his left arm is too nice for a dalliance, so the naughty girl on his right arm will entertain him as he awaits fulfillment with his dream girl. On his chest is the other woman of importance in his life: the Virgin Mary, largest of the three.

The *Wrong-Headed Hombre*'s ultimate devotion is to the mother figure or matriarch, represented by the *Virgen de Guadalupe*. *Hombre Que le Gustan las Mujeres* represents the same three tattoos on another burly *bato*, this time with only one head. His expressive face reflects his sincerity. A background of green is broken by flashes of black, white and red, adding intensity to the portrait and suggesting the Mexican national colors.

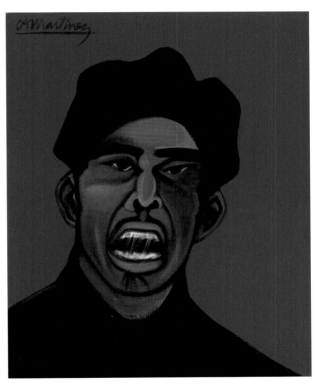

Figure 4
Screaming Bato (cat. 3)

SOUTH TEXAS SERIES

The *South Texas Series* was started by Martínez to represent the unique environment of the region in which he was raised. It is a reflective series, looking back nostalgically on weather and climate conditions he remembers vividly from his childhood in Laredo and on the family's ranch in Northern Mexico. He also reflects on South Texas legends in these works. One that was discussed previously was *El Señor de los Milagros* (pl. 25)

where the legendary Don Pedrito Jaramillo is presented as a "miracle worker."

The Scream in South Texas (La Llorona) (pl. 29) represents another South Texas legend in a triptych format. Above a brittle landscape with a cracked riverbed running through it is placed a ghoulish mask with two hands below it. On the wings of the triptych are devotional candles also seen in *El Señor de los Milagros*. The skeletal visage is a representation of *La Llorona*. There are several versions of the story of *La Llorona* – the Crying Woman who can be heard at night along the waterways. She drowned her children in the river and now searches for them futilely.

In *The Scream in South Texas* and *El Señor de los Milagros*, Martínez begins to use found materials in combination with paint. This interest in discarded materials from the environment characterizes many of these South Texas images, as well as images from the subsequent *Mestizo Series*. Benito Huerta identifies the use of found materials as an example of *Rasquachismo*[6] – which is a Chicano aesthetic intended to repudiate the Anglo experience. Martínez's insistence upon the use of discarded materials, such as worn pieces of wood and cast off car hoods, may also be influenced by his training in the Modernist aesthetic. The use of found materials is an important

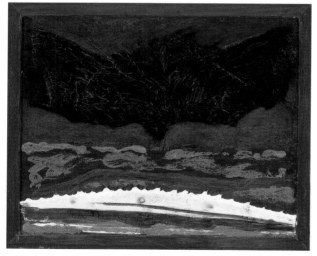

Figure 5
Forma Goyesca Sobre la Tierra de las Espinas (cat. 34)

element in 20th century art, as in the work of artists like Kurt Schwitters and Joseph Cornell.

In fact, Martínez directly acknowledges his debt to Western traditions in images like *Forma Goyesca Sobre la Velada de los Refugiados* (pl. 23) and *Remolino Coloso (For/After Goya)* (pl. 30). In the titles of these paintings, he refers to the Spanish artist Francisco Goya. *Forma Goyesca Sobre la Tierra de las Espinas* (fig. 5) is filled with diffuse and hazy forms, predominated by a dark, ominous bat-shaped form hovering in the central frame. A more clearly defined bat can be seen in *Forma Goyesca Sobre la Velada de los Refugiados*. The bats relate to the tormented Goya of later years. Goya used them in *The Sleep of Reason Produces Monsters* (1796-98) and in his late scenes of witchcraft. *Remolino Coloso (For/After Goya)* has a form emerging from the center which also appears to be a bat. The painting is predominantly hazy and mysterious – a great, blended abstraction, except for the animals which are barely perceptible at first. Birds are placed on the far right while javelinas, a coyote and rabbits are represented on the far left. Two dark outcroppings, one in the foreground and one in the middle ground, provide a visual balance to the dark threatening sky. Sweeping upward into the darkness is a tremendous dust devil that obliterates a substantial portion of the landscape.

Turmoil in South Texas (pl. 22) uses corrugated metal and barbed wire to create a serpent form represented against a luminous sky. This painting, like others in the *South Texas Series*, has a dreamy, magical presence that casts a veil of memory over the landscape.

The serpent is used in these paintings for a number of different reasons. First, it is a common creature in the South Texas and Northern Mexico environment. Secondly, it is significant in ancient pre-Columbian ideology. The snake was considered a god because he was an anomalous creature for having the ability to live in the sky (in the trees), on the land, inside the earth, and in the water. As such, the serpent bridges the three levels of the universe – the Upper World (heaven), the Earth, and the Underworld. He was also revered for his

ability to shed his skin, as appears to be the case in *Remembering a Dead Snake in South Texas* (pl. 24). Lastly, the fact that the snake can be deadly to humans makes him a respected creature by ancients and moderns alike.

Amor a La Tierra (en el Sur de Tejas) (fig. 6) is painted on a "no trespassing" metal sign. It is an evocative image that in a deeper sense, alludes to the former Mexican land owners losing their land to powerful American interests. Another such image is *Parece Que Viene Agua (Looks Like Rain)* (pl. 28) which deals with the changes that take place with the appearance of rain. South Texas is frequently a drought-ridden area so that rain is anticipated with great hope. Martínez has adorned the left side of the painting with snail shells – symbolizing the snails that would climb up walls and the brush when rain was imminent. He uses painted metal to represent storm clouds and a rainbow appearing over an open plain.

Parece Que Viene Agua (Looks Like Rain) and other images of the *South Texas Series* celebrate Martínez's affinity with his environment. Martínez is an avid outdoorsman who loves to fish. As a youth, he also enjoyed hunting. He spent a great deal of time with some enthusiastic hunters in the 1960s. One of his hunting buddies, nicknamed "El Cono," died in the early 1970s. As a tribute to his friend, Martínez painted *Cono's Christmas Buck (South Texas Lascaux)* (pl. 31) The title refers to a buck that "El Cono" had killed at Christmas time which ended up as *tamales de venado* (venison tamales) that are a particular delicacy at this time of the year. The subtitle, *South Texas Lascaux*, refers to the worn, graffiti-like appearance of the superimposed images etched on the wooden surface. It is ranch, not urban graffiti, as Martínez says, things that a hunter might inscribe on the wall of a shack. Lascaux is the Paleolithic site of cave paintings in France. Martínez's antlers relate to animals painted for hunting rituals in the ancient caves. His spray-painted outlines of hands that serve as a signature in the painting also refer to similar images discovered in

Figure 6
Amor a la Tierra (en el Sur de Tejas) (cat. 32)

the Paleolithic cave paintings. The hand also refers to Martínez's interest in the cultural aspects of the Catholic religion in Chicano society. In this context, the hand symbolizes the *Mano Poderosa* or the Powerful Hand of Christ.

THE MESTIZO SERIES

Martínez developed the *Mestizo Series*[7] as a means of exploring the confluence of cultures that is a part of his heritage. He believes that he is equally indebted to the traditions of pre-Columbian, Colonial Mexican and Modern European and American art. A good example of the intermingling of traditions is *Mona Lupe: The Epitome of Chicano Art* (fig. 7). This image combines the symbolism of Mexico's *Virgen de Guadalupe*[8] with the figure of Leonardo da Vinci's *Mona Lisa* (c. 1503–06). In the tradition of Marcel Duchamp's *L.H.O.O.Q.* (1919), the use of the Mona Lisa is an irreverent parody of one of the epitomes of high art. Irreverence to the *Virgen de Guadalupe* - the most venerated apparition of the Virgin Mary in Catholic Mexico - is also implied by the pairing of her iconography with the secular visage of the Mona Lisa. The colorful costume, the rays of light, and the slice of moon are juxtaposed against the quizzical and enigmatic facial expression borrowed from da Vinci. As a whole, the pairing is humorous.

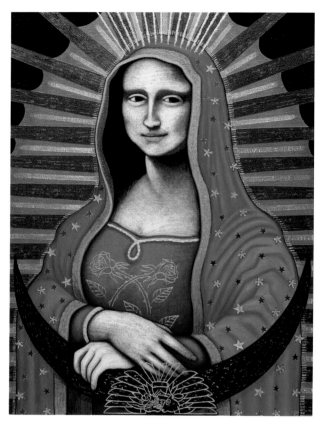

Figure 7
Mona Lupe: The Epitome of Chicano Art (cat. 53)

The subtitle, *The Epitome of Chicano Art*, relates to the intermingling of the multicultural influences that is found in contemporary Hispanic art.

Reinvented Icon for this Time and Place (San Antonio) (pl. 37) also reflects the many layers of culture that make up Martínez's artistic heritage. Here he creates a new icon that includes pre-Columbian, Colonial and Modern references. From the pre-Columbian culture is a pyramid surmounted by the Aztec goddess Coatlicue. Coatlicue doubles as a crucifix representing the Colonial era. Also from the Colonial epoch are the moon of the *Virgen de Guadalupe* and a representation of the figure of the *Virgen de Guadalupe* inside the Rose Window from Mission San José in San Antonio. The Rose Window comprises part of the chest of

the Coatlicue. The hands at the base of the pyramid are an ancient symbol.

Martínez uses Christian symbols, not because he is particularly religious himself, but because he knows that members of the Hispanic community can quickly identify with these culturally-charged images. Also, these icons were prevalent in the formative years of his life. Modernist influence is evident more in the rough surface treatment of the paint rather than through specific icons.

The confluence of cultures in *Reinvented Icon for this Time and Place (San Antonio)* exhibits a contrasting attitude about cultural heritage. In Mexico during the Colonial period, the populace was made to feel ashamed of their Indian heritage by the development of a complex caste system that ranked people in accordance with the ethnicity of their parentage. The highest caste belonged to those of pure Spanish blood. The lower castes were assigned to those with a great deal of Indian blood. In order to illustrate the caste system, paintings were made to demonstrate the characteristics of each class. These paintings continued to be made into the 19th century and represented stereotypical images. The more Spanish blood, the more refined and well-mannered the individuals were considered to be. On the lower end of the scale were the Indians who were depicted as drunk and miserable, beating their families into submission.

The great Mexican muralist, Diego Rivera, was aware of this attitude and he systematically set out to change it in his propagandistic mural paintings. In the National Palace in Mexico City, Rivera created a series of murals (1929-30, 1942-51) that showed the ancient civilizations of Mexico – the Aztecs, the Totonacs, and the Zapotecs, among others. In these paintings, Rivera created idyllic images of peaceful Indians in clean and prosperous surroundings, working diligently at their crafts and the cultivation of their fields. He purposefully ignored the more negative aspects of pre-Columbian culture, such as warfare and human sacrifice.

In other murals in the National Palace, he represented the conquistadores as destroyers of these "peaceful"

cultures. The *conquistadores* are shown maiming and enslaving the Indians. Rivera's radical (although inaccurate) portrayal of the Indian past was purposefully done as he was trying to instill a sense of pride in their Indian heritage into the people of Mexico. Martínez goes a step beyond Rivera. He shows the Indian past through recognizable icons. Unlike Rivera, Martínez does not malign the Spanish influence. Instead, he superimposes this heritage on the pre-Columbian, acknowledging his indebtedness to both.

In a series of drawings for a 1914-18 mural project, the Mexican artist Saturnino Herrán created *Coatlicue Transformed* (1918) as the centerpiece for an unrealized mural project called *Our Gods*. [9] In Herrán's image, the crucified Christ is superimposed upon the Coatlicue image. In Martínez's *Quinto Sol: Cruz Mestiza* (pl. 38), the crucifix with the nail-torn hands of Christ is layered with the Rose Window from Mission San José in San Antonio, a statue of the Virgin Mary, and Coatlicue. Martínez's Virgin stands out prominently because of the bright pink and blue that she is wearing; in essence, she becomes the central motif. [10]

Martínez's superimposed image of Coatlicue and the Virgin Mary in *Quinto Sol: Cruz Mestiza* symbolizes this Colonial replacement of one religious icon with another. The title of the painting means *Fifth Sun: Mestizo Cross*, and refers to Aztec mythology. The Aztecs believed that the world had been created and destroyed four times in the past and that they were living in the fifth creation or sun. Martínez's title connects the fifth creation with the amalgamation of pre-Columbian and Colonial elements.

At the bottom of the side panels of *Quinto Sol: Cruz Mestiza* are lacy forms which symbolize another important influence in Martínez's life. This lace is an autobiographical reference to his childhood. Martínez's father died when he was less than a year old and he was raised in a house with his mother, grandmother and aunts. Patterns relating to this influence also appear in

Soñando con los Angelitos (pl. 34) where the overlapped circular forms on the bottom mimic quilting shapes. Martínez, whose grandmother was a quilt maker, feels that the women who raised him encouraged him to become an artist.

In looking over some Picasso sketchbooks, Martínez found some images of a bull with man-like features that influenced him to produce a series which includes *El Mestizo* (pl. 43)

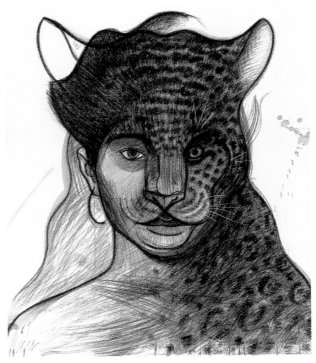

Figure 8
Las Américas (cat. 69)

and *Europa* (pl. 44) and *Las Américas* (fig. 8). The intermingling of European and native American cultures – the *mestizo* character – is represented by the interlocking images of the jaguar, man and bull in *El Mestizo*. These forms are united against a vibrant background of cacti.

Martínez aligns the bull with European culture and the jaguar with pre-Columbian culture. In *Europa*, a man is undergoing a transformation into a bull and in *Las Américas*, a woman is transforming into a jaguar. In pre-Columbian mythology in the Olmec region, there was a legend of a superhuman race evolving from the mating of a woman with a jaguar and such transformative figures appear in Olmec art. The ancient European legend of the Minotaur, the half-man, half-bull creature in Picasso's sketchbooks appears in Martínez's *Europa*. Combined together with the single masculine face in *El Mestizo*, they refer to the collection of European and native American influences that have impacted upon Martínez's imagery and style. For Martínez, all of art history is a visual catalogue available for his use. Francisco Goya, Pablo Picasso, Paul Gauguin and Vincent van Gogh are as useful to him as the Aztecs' Coatlicue or the Colonial Rose Window from Mission San José in San Antonio.

The New World in opposition to the European world is symbolized in images relating to the bullfight that Martínez has created throughout his career. Representative of these images is *Calavera Torera* (pl. 50). *Calavera Torera* shows a *calavera* [11] from the Mexican tradition of José Guadalupe Posada smiling sardonically and hovering over the image of a bull. This work is a linocut with watercolor on paper that incorporates the black and white representations of the bull and *calavera* against an orange field, adding great intensity to the images.

Martínez had originally wanted to be a bullfighter and had spent a great deal of time at bullfights training to be one in his younger years. Recently he has returned to training in the bullring. He believes that the bullring is an excellent place to see the distinction between Spanish and Mexican cultural styles, reflecting the unique character of the *mestizo*. In observing some Spanish bullfighters, Martínez has noted a very cold and technical manner. While watching Mexican bullfighters, Martínez has discovered a more soulful approach to the performance. He believes that these characteristics are a result of the amalgamation of European and Native American influences into a more emotive *mestizo* culture.

Recently, Martínez has been working with monotypes, a technique that he first began to explore in 1985. In particular, he made a large series of monotypes during his ArtPace residency in 1997. These images elaborate upon the superimpositions first begun in the *Mestizo Series*. The monotype process particularly lends itself to creating a veiled quality of multiple forms, further strengthening the emphasis on multiple sources that comprises so much of Martínez's art. He is willing to identify his Chicano heritage as a confluence of European, contemporary American and Native American elements. Stylistically informed by the strong traditions of Modern and Contemporary art, Martínez incorporates pre-Columbian and Colonial imagery to reaffirm the depth of his rich artistic legacy.

Dr. Carey Clements Rote
Professor of Art
Texas A & M University – Corpus Christi

1. Stokstad, Marilyn. *Art History* (New York: Harry N. Abrams, Inc., 1999), p. 994.

2. The pre-Columbian people created art and literature that dealt with male versus female, darkness versus light, health versus disease and the day versus the night, among other oppositions. In Aztec religion, the opposition of day and night is symbolically rendered through Huitzilopochtli, god of war and the sun, and his sister Coyolxauhqui, goddess of the moon. Coyolxauhqui is "slain" by her brother at the appearance of the sun each morning.

3. Torres, Eliseo. *The Folk Healer: The Mexican-American Tradition of Curanderismo* (Kingsville, Texas: Nieves Press, 1999), pp. 35-39.

4. *Vato* or *bato* is a Chicano slang term that means guy or dude. The *ruca* is the female counterpart. Pachuco refers to the Mexican-American zoot suiter of the 1940s and 1950s.

5. There are a number of artists in past history who have also glorified the common man. For instance, the Spanish painter Diego Velásquez, in an image like *The Water Seller of Seville* (c. 1619), presents an ordinary person with lucidity and grace. Refer to Stokstad, Marilyn. *Art History* (New York: Harry N. Abrams, Inc., 1999), p. 778. A more recent example is Diego Rivera of Mexico whose goal was to glorify the humble Indian inhabitants as the noblest residents of his country. In images like *Flower Day* (1925) and *The Tortilla Maker* (1925) he represents the poor in a state of innocence and purity. *Mexico: Splendors of Thirty Centuries* (New York: The Metropolitan Museum of Art, 1990), pp. 662-623.

6. "'Rasquachismo' is a Chicano aesthetic: taking kitsch or found or trashed material and transforming them into art." The term is derived from the Spanish word for white trash – *rasquache*. Refer to Huerta, Benito. "Cultura de South Texas" (Corpus Christi, Texas: Art Museum of South Texas exhibition catalogue, 1998), p. 8.

7. *Mestizo* is a term that refers to the blending together of two races. The *mestizo* that Martínez refers to combines the blood of the native Mexican populace with the blood of the Spaniards who conquered Mexico.

8. The *Virgen de Guadalupe* was a miraculous apparition of the Virgin that appeared to an indian named Juan Diego on four separate occasions in 1531. A miraculous image from the second apparition of the *Virgen de Guadalupe* is housed in the Basilica of the Virgin, which is located at the foot of the hill of Tepeyac in Mexico City on the site where the apparitions took place. The special feast day for the Virgen is December 12th to commemorate the appearance of the miraculous image on the cloth of Juan Diego's cloak. Martínez uses the elements of this image which were established in Mexico in the early 17th century, making her readily identifiable to Mexican Catholics. Incidentally, the site where the apparitions occurred happened to be on a hill dedicated to the Aztec earth goddess, Tonantzin ("Our Mother").

9. The drawing of *Coatlicue Transformed* by Saturnino Herrán was shown April 6 – August 4, 1991 in San Antonio as part of the exhibition, *Mexico: Splendors of Thirty Centuries* organized by the Metropolitan Museum of Art, New York. Also, Jacinto Quirarte, "The Coatlicue in Modern Mexican Painting," *RCA Review*, Vol. 5, No. 2, April 1982, pp. 1-8.

10. Coatlicue was an Aztec goddess whose name means "She of the Serpent Skirt." She was a goddess of birth and death with horrific aspects. Her skirt is composed of writhing snakes and her arms and head have been replaced by serpent heads. Her necklace is composed of a skull, severed human hands and extracted human hearts. In Aztec mythology, she was the mother of 400 children. One day she picked up a blue feather and was impregnated by it with her 401st child. When she told her other children, they plotted to kill her under the leadership of her daughter Coyolxauhqui. Together the children chopped off Coatlicue's head and when they did the son in her womb emerged full-grown, dressed in armor. He was Huitzilopochtli, god of war and the sun, and he slew his sister, Coyolxauhqui, by severing her head, arms and legs. Coyolxauhqui was the goddess of the moon and the battle between her and Huitzilopochtli symbolized the daily battle between the sun and the moon. Every morning the sun vanquishes the moon with its appearance, along with his 399 other siblings, who represent the stars is the heavens. During the conquest, the Spaniards saw such a statue of Coatlicue covered with blood and determined to replace it with a more benevolent Christian image or the Virgin Mary. The same systematic replacement was true in the Maya region where the goddess Ix Chel, "Lady Rainbow," was the Moon Goddess and the old goddess of weaving, medicine and childbirth. In her statues, she was shown with snakes in her hair and claws in place of her feet and hands. As such, she appears to be a close parallel to the Aztec Coatlicue. At the site of San Gervasio on the Maya island of Cozumel a devotional statue of Ix Chel was set up in a temple. This was a pilgrimage site for Mayan women. When the Spaniards arrived, they replaced the statue of Ix Chel with the statue of the Virgin Mary. Coe, Michael D. *The Maya* (New York: Thames and Hudson Inc., 1993), pp. 176-177.

11. *Calavera* is a term that refers to skeleton figures that are represented in various lively posturings. They are related to the Mexican celebration in the Day of the Dead. They are sometimes shown to express moralizing tales. The great Mexican printmaker, José Guadalupe Posada, is particularly well known for his many renditions of the skeletons or *calaveras*.

AN INTERVIEW WITH CÉSAR A. MARTÍNEZ

This interview, with artist César A. Martínez, was conducted for the Archives of American Arts, Smithsonian Institution, in August, 1997, during the time of his residency at ArtPace, A Foundation for Contemporary Art, in downtown San Antonio. The interviewer is Dr. Jacinto Quirarte, Professor of Art History, The University of Texas at San Antonio.

JQ: Well, César, this is really a wonderful opportunity to document some of the things that we've talked about over the many years that we've known each other. So, tell me a bit about your growing up.

CM: I grew up in Laredo, Texas, which is where I was born on June 4, 1944. Laredo is on the border with Mexico, and so I had a lot of visits from my family in Mexico and Spanish was my first language. I also spent a lot of time at the family ranch in northern Mexico in my formative years. I would say that in recent times a lot of the imagery is coming from those early childhood experiences, getting more biographical.

JQ: Did you have anyone in your family who inspired you to become an artist? How did you begin to make images?

CM: The only person that I can identify in my family as having some kind of artistic talent is my cousin, Armando. I remember that he used to do a lot of nice drawings. But I remember also that a family friend was an artist. I think that all of those things stirred something in me. There was something about drawing and painting that was very interesting to me.

Being an only child, I was indulged, and if I showed an interest in art, my mother and my aunts would buy me colors, stuff like that.

JQ: What about images in your house when you were growing up? What are the first pictures you remember?

CM: I don't really remember too many – or anything. I do remember a little bit about the old calendars and things like that.

JQ: What about religious images? Did your family include home altars or anything related to it?

CM: My grandmother had a little altar, which was very, very noticeable. I don't think I ever really showed a particular interest in it. Other than that, I took it for granted. It was always there.

I remember that one of my aunts, my aunt Lydia, was a very avid picture-taker. She had this old box camera, a "brownie." And very early on, she bought me one. I would take a lot of pictures and I also took a lot of interest in the family album. It was bulging with family photographs, and there was some very old stuff in there. I intend to go back to it one of these days and maybe do something with all the images.

The richness of the images always caught my eye because, I guess, I had an eye for it, to start with. But as I said earlier, I'm the only one in the family who ever developed it.

JQ: What kind of images did you see when you first started school? Were you in school in Laredo or Nuevo Laredo?

CM: In Laredo. I don't recall ever having any activities involving the visual arts.

I think it was not until the fifth or sixth grade that I remember having any. I remember that apparently I had shown some kind of talent in school because I was one of those kids who was always getting pulled out of class to work on a set for a play.

I remember I liked wildlife, and I did some drawings for a contest. And some animals, copies of them actually.

So, I don't think I really had any idea but I think the mechanics of it fascinated me: being able to draw.

JQ: Did Laredo have an art museum when you were growing up?

CM: No, it did not. And it still doesn't really have one.

JQ: So, did the art teachers in high school show you any reproductions?

CM: Yes, well, books. I think that the first actual art class that I took was when I was in junior high school. It must have been the ninth grade, taught by Mrs. Quiroz.

I remember the big achievement of the year for me was that, again, I got pulled out of a class to work on a parade float for the annual parade in Laredo, a very big thing over there. I remember we had a bull fighter on it. One of my friends was dressed as a bull fighter and I think that's another thing that piqued my interest in those years.

But that was the last – through high school, I didn't take any art classes because I got very realistic and I was thinking, "Well, you can't make a living as an artist." So I took business classes. It wasn't until my third year in college that I studied art. I spent two years in Laredo Junior College, studying business administration, which I hated. I was very naive. I thought, "you study this and then – and then you're qualified." I thought that everything comes automatically, you don't even have to look for a job. You start working, you know, automatically.

And from Laredo Junior College, I went to Texas A & I University in Kingsville. The first semester went so badly in business administration that I decided to go into what they call the all level art education program there, as that was the only way that you could take a lot of art courses. It was perfect for me, and I avoided all those other harder courses for a B.A. program. I wasn't a very good student and had no interest in school, really. But in those college days it was affordable and my family was paying for it.

I arrived at A & I in September of 1964. I wasn't really college material but I went. It was being paid for.

As soon as I went into the art program, I started doing all right. My college career stabilized and I got a Bachelor of Science degree in all-level art education.

JQ: What kind of teachers did you have? Were there any that inspired you, or you were just getting through the program?

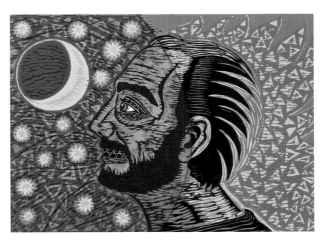

Figure 9
Tranquilidad del Vato Quemado (cat. 70)

CM: It was a very interesting time, and the teachers there are now like family. We are very good friends; at the time, to tell you the truth, I really didn't appreciate them as much as I do now.

But these were times when things were changing politically – and I was very naive politically, in every way, really. So at A & I there were two people who became very important to the Chicano Movement in Texas, José Angel Gutiérrez and Carlos Guerra.

José Angel was already on his way out when I got there. He is older than me. Carlos was a year younger than I was.

Carlos Guerra is now a columnist for the newspaper here in San Antonio.

It was basically through Carlos that I became very conscious of the political things that were happening.

JQ: How many faculty did they have?

CM: I think there were about five or six in the art department. And the art professors were very liberal, all of them, even Mr. Bailey, who was an older man, an older military man. He was the head of the art department. They were also working, producing artists and each of them had a studio there and I was very interested in what they were doing professionally.

I did very well in art classes but what fascinated me more was the idea of being an artist. My thinking was, "How are you just an artist?" But there was no road map for that. You just have to go with it. If that's what you want, you have to figure out a way. The instructors taught us the mechanics; as far as content, they pretty much left that to us.

So I was able to explore a lot of things. As far as art history is concerned, these were the years at the end of the Abstract Expressionist movement and where abstract art is concerned, color-field painting was the thing. Jules Olitski, Mark Rothko and Kenneth Noland. I liked their work.

Pop art was coming into its own, and that interested me a little bit, although not as much as just the pure act of painting. So basically I was starting to become an abstract painter.

My intention, when I finished college, was to go to New York and be a New York artist. That was what I read in the art magazines, and I was buying all of it. And that never happened. Eventually, I got drafted. These were the Vietnam years.

JQ: What year were you drafted?

CM: As soon as I had graduated the draft got me, in August of 1969. I wound up in Korea.

JQ: So, afterwards you came to San Antonio?

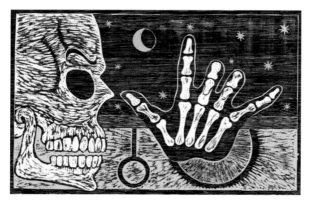

Figure 10
Vacilando (cat. 72)

CM: I came to San Antonio because my friends from college, Carlos Guerra and Beto Peña and some other people who were very close to me were here. They were already activists in the Chicano Movement.

JQ: Now when did you meet some of these Chicano artists? Or when did you begin to hear about Chicano art?

CM: I think that almost immediately I was introduced to some artists who were already organized here. I remember meeting "Chista" and Rudy García, known as "El Diamond."

Others I met were Jesús María Cantú, Mel Casas, José Esquivel, and Jesse Almazán. They already had a group going. I don't remember exactly what the name was because it went through several incarnations.

JQ: I remember they said it was *Tlacuilo*.

CM: Yes, the *Tlacuilo Group* and it was also *Pintores de La Nueva Raza*. Then it became *Con Safos*, which was the most visible of the groups.

JQ: Now, did you belong to *Con Safos* or you were just on the periphery?

CM: Not initially but I was drawn in eventually. Basically the recruiter there, the gung-ho guy, was Felipe Reyes.

Even though Mel Casas was pretty much identified as the figure head there, it was actually Felipe who was doing a lot of the work. It was through Felipe that I got in and I stuck to *Con Safos* for a couple of years.

JQ: What prompted you and Carmen Lomas Garza and others to form *Los Quemados*?

CM: I had a real political connection in that I was working with the Texas Institute for Educational Development. Carlos Guerra was the head of that. These other guys, even though they were perfectly in tune with the events of the time, the Chicano movement and everything, they were basically in it as artists, and I was coming at it differently.

JQ: So, you were doing photography at that time?

CM: Yes. But basically what we did at the Texas Institute for Educational Development is that we would work

with local activists in small towns in South Texas like Cotulla and Robstown.

We would have meetings and then discuss all kinds of things and strategies for organizing. And since I was an artist we figured a cultural thing to it, which was my part, and I would give a little talk and show slides of what artists were doing.

JQ: Where did you get the funding for that?

CM: Eventually I got funding from the Irwin Sweeney Miller Foundation. They gave me one grant that I had applied for through the fundraising effort of Carlos Guerra, who was a very effective fundraiser.

The grant allowed me to travel throughout the Southwest and photograph the works of Chicanos who were involved in the movement. I came up with a pretty good collection of slides that we eventually sold to libraries.

JQ: Yes, because I saw them. Good documentation as a lot of those murals disappeared right after that. What year was that?

CM: That must have been 1973 or 1974. Basically what I covered was Texas, New Mexico and California. I did put together a very fine collection that probably became seminal for Chicano arts study.

JQ: So, coming back to your painting. When you were involved with the Texas Institute for Educational Development you were still doing prints and paintings?

CM: The only work that I managed to do was some painting immediately after I got to San Antonio. But I was doing hard edge things, abstract stuff, again exploring my interests in college, which was basically color-field painting.

And I was doing some pretty good work, I think, but in those early shows I was getting a lot of *carilla* –

JQ: *Carilla?*

CM: *Carilla*, they were on my case, so to speak. A term that means they were harassing me about it.

JQ: Harassing you?

CM: Yes, it was very bourgeois, you know, and all that rap.

JQ: Because you weren't doing politically charged things?

CM: No, I was not doing any of that. But, I was basically exploring it and so the insight that I got from that is that figurative work was harder for me to do than abstract work. I didn't have the technique or anything. And, what happened is that when I went to California with the project that I did, I met a lot of artists who had the biggest influences on me: José Montoya and Manuel Hernández in Oakland; Salvador Torres, "El Queso," in San Diego. I thought they were doing some very original stuff, and they influenced me where subject matter is concerned. Also José's brother, Malaquías. Malaquías and Rupert García were very important to me.

Rupert was doing posters and he was very helpful to me; we have become very, very good friends.

It was Hernández who influenced me on those woodcuts. I came back after that trip wanting to do woodcuts and I did some. And those were the first works that were shown in the Chicano context.

JQ: They included some of those in *Ancient Roots/ New Visions?*

CM: Yes, that gave them a lot of visibility and then one of those got reproduced everywhere. My first hit! I was starting to move into figurative work because I felt that the idea that was germinating in me needed to be expressed figuratively, and I did not have the technique that I needed for that. So it took a few years for me to get my bearings and that eventually led to the *Pachuco Series* in the late 1970s.

Right before that I had done the very hard edge *Serape Series*, which was sort of a transitional period. Curators were really gravitating toward that series. Since then, I have added other things.

JQ: Now, you have told me on other occasions that you began then to recall some of the people you knew

when you were growing up and in some cases, you used photographs.

CM: Let me tell you how all of that came together because influences are very important. As you know, I mentioned visiting "El Queso," earlier, in California. He had some sketch books and I went through them. And I saw some of the most stunning images of Chicanos that I had ever seen.

I mean, who would think of painting some *pachuco*? And "Queso" was doing that. Not in a stylized way, like José Montoya. They were just regular excellent drawings in charcoal and pencil, but of real people.

JQ: Not caricatures?

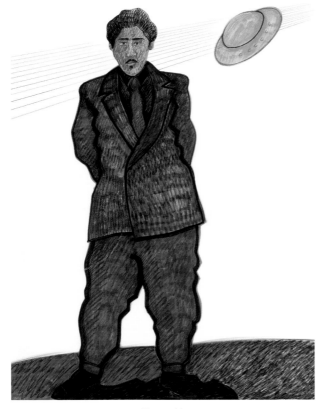

Figure 11
1940s Style: UFO and Pachuco (cat. 57)

CM: Not necessarily just *pachucos*, but people in general around the *barrio*.

And I said, "I want to do stuff like that." It moved me. Being into photography at the time, I was looking at a lot of the work of Richard Avedon, with all of those very frontal, very poker-faced portraits that he was doing.

JQ: Right.

CM: And then Fritz Scholder, the Indian artist was doing a lot of very frontal stuff with Indian imagery, and all of these were working on my mind and I was forming an idea of what I wanted to do with these portraits.

I was also sort of tipping my hat to color-field painting with what eventually developed in those stark backgrounds in my work. So I think I owe something to Richard Avedon and, to some extent, Fritz Scholder. Picasso, at the turn of the century, did a lot of very wonderful portraits of the ambiance that he was in, and Toulouse-Lautrec had done a lot of stuff like that. Degas, Gauguin and van Gogh, all of those artists *también* and many others throughout history.

JQ: But the Mexicans didn't affect you at all?

CM: Ideologically.

JQ: In terms of images?

CM: I was never really drawn to that.

JQ: Because you were never interested in the murals the way those artists out in California were?

CM: No, I never was interested in it. I think that the artists here generally, we all work individually, whereas in California it was a very collective thing, and I think that's one distinguishing thing from the Texas tribe and the California tribe.

JQ: That's right.

CM: But, anyway, all these things that I mentioned were going around through my head, and I think basically that is how the *Pachuco Series* eventually emerged.

It's not really a style in which they were done. I've always said that I found the format for these characters that I wanted to depict and that is how the idea formed. Sources? Well, one of my very first sources was the high school yearbook.

JQ: Oh, is that right?

CM: Eventually I put together pictures from magazines that struck my eye. And I collected them as a reference. And so that's where I get my images. But a lot of them are from my recollections.

Probably the most effective images have been reconstructed from my recollections. I would kind of merge characters, make composites.

I was also very consciously working with physiological types that you would recognize, that you could say, "Yeah, I know that guy!" I think we all fall into types.

JQ: The *barrio* type.

CM: Yes. Well, not the *barrio* but, you know, physiologically there are certain people who look a certain way; some look very Moorish, some very European, some very Indian. A distinct physical type.

I was working with all of those physiological types, trying to come up with characters that were very specific but at the same time also very universal to the Chicano experience.

JQ: So, whenever you started a particular direction, you never really abandoned other concepts.

CM: No, I have never abandoned anything.

JQ: When did you start the *South Texas Series* or whatever you call it?

CM: The *South Texas Series* had been there in my mind forever, I would say. But like I said earlier about the *Pachuco Series*, I needed to find a format, a way of doing it.

I went into a painting style that was expressionistic.

My mind was working and I was coming up with this stuff, and "How do I do it effectively?" I actually did some landscapes, what I called the *Río Grande Series*, which were very simple, just sky and land and a river going through it. Basically what we have in the *Pachuco Series*, backgrounds only, a basic horizon line there; but it didn't work. It wasn't effective.

JQ: You didn't have enough possibilities.

CM: Yes, here's where I became conscious of the fact that what worked for a particular subject doesn't work for something else.

That is where I started forming ideas about style. I came to the conclusion that, in my case, style would have been something superficial. I was just trying to do something in the style of the *Batos* or the *Pachuco Series*. But it didn't work for that series, so I said, "I need something else." And eventually it became a mixed

Figure 12
Veterano (cat. 5)

media thing and also very expressionistic where the painting was concerned.

Eventually I found my format for the *South Texas Series*. But it had been in my mind forever.

JQ: So did the use of found materials open up new possibilities?

CM: Yes, these were wall pieces. They're sort of like painting, and they actually have some painting in them, and also, a sculptural element. I did some snakes out of barbed wire that were three-dimensional and these were attached to the wall pieces.

I just included it but it's not conceived as a sculpture.

JQ: But in that series, you also have a lot of remembrances or reminiscences of your growing up in South Texas.

CM: Yes, because I was pretty much into the outdoors – fishing and hunting, coming from a ranching family. I spent a lot of time at the family ranch in Northern Mexico. Eventually all of these become subjects. For example, probably one of the most effective pieces from the *South Texas Series* is the mixed media piece that I called *Cono's Christmas Buck*. "El Cono" was a friend of mine from Laredo who passed away in the early 1970s.

But when we were in college in the 1960s, he was very much into hunting and he was very expressive in

Figure 13
South Texas Schism (cat. 33)

the way he would recount his hunting adventures, and very funny also.

The year that I was floating around "dodging the draft" I would go back to Kingsville to stay with my friends. And they all lived in this house together, "El Cono," and Beto Peña and other friends of mine – people that I hung out with.

I would stay there. We'd be there shooting the breeze in the evening and I'd be talking about art and "Cono" would get exasperated with me.

He would say, "*Platícame de carabinas*," talk to me about hunting. It was very funny. So when the *South Texas Series* came together, "Cono" came to my mind, and I said, "Now, who would think of using "Cono" as a subject except me?" So, I worked out this piece, and basically it's ranch graffiti that some hunter might inscribe on the wall of a shack where he is staying. "Cono" was the subject of one of the most effective pieces in the *South Texas Series*. It was basically a story told through graffiti about a buck that he killed for the Christmas tamales because it's a tradition in Laredo. *Tamales de venado* are a big thing in Laredo.

JQ: What about the exhibitions that became very important in the late 1970s? You were in that major international show, *Ancient Visions*?

CM: Yes, *Ancient Roots/New Visions*. It was one of the first major museum exhibitions that traveled nationally.

JQ: You were also in *¡Mira!* sponsored by Canadian Club?

CM: Yes, Canadian Club was the sponsor. Later, there was the Coors thing which I did not participate in because I had a political problem with Coors. A lot of artists did; we didn't want to be involved with Coors because of its right-wing founder.

So notwithstanding, some very good artists participated in that. I was included in quite a few early Chicano exhibitions; it wasn't until relatively recently that I started being left out of major shows.

JQ: Oh, is that right? But you were in *CARA*?

CM: Yes, but exhibitions have become more specialized and competitive and new artists emerged. And I'm getting old.

I think that what happened is that they became more and more fragmented. Tomás Ibarra Frausto and Amalia Mesa-Baines began to do things in San Francisco and other places, and if you didn't fit into their notion of Chicano art, then you were not part of it.

These early shows were national in scope, and then people started to organize major shows in their own locations, like California. Here in Texas we had *Dále Gas* in Houston in 1977.

In California, prior to these what I think is probably the first Chicano museum show was *Los Four en Los Angeles*.

JQ: That was in 1974 at the Los Angeles County Museum?

CM: Yes, Jane Livingston put that together.

JQ: Well, of course, there hasn't been any really major Chicano shows since *CARA*.

CM: No, probably the last major one was *Hispanic Art in the United States*. It wasn't a Chicano show because that was the last of the major surveys. I think it started in 1987.

JQ: Jane Livingston and John Beardsley were the curators. I believe it was done for the Corcoran, in Washington, D.C., and Houston. But your *Pachuco Series* was already very well known by then.

CM: Yes, in fact, that is what was shown in that show, and after that I've been in many museum shows. Actually, it's kind of interesting that artists would kill to be in museum shows, and I started to become conscious of, "Well, what's this thing about museum shows?" And it turns out that most of the shows that I had in my resumé at the time were museum shows.

I didn't have any gallery shows. It wasn't until recent times that I started showing in galleries and selling a painting.

JQ: So, who handles your work? Do you have a gallery?

CM: Over the years I've had different galleries handle my work, in Houston, New York, Austin and San Antonio.

JQ: Let me backtrack a little on something that we left out relating to your work in the mid-1970s when you were involved with *Con Safos*, although you did become involved with *Los Quemados* (the burnt ones) as a reaction to what *Con Safos* was doing. Can you tell me a little bit about that?

CM: I was involved with *Con Safos* and I became a member. But I had always felt the San Antonio artists were a very tight group. But with my political ties I knew a lot of people throughout the Southwest.

And here in Texas, I was very good friends with Amado Peña and Carmen Lomas Garza, José Treviño, Vicente Rodríguez and Santa Barraza. So when I went into *Con Safos*, a lot of them came in with me.

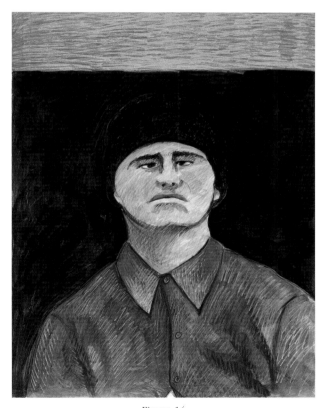

Figure 14
Low Rider Bizco (cat. 59)

And after we had been in *Con Safos* for a while, we started noticing a pattern in the meetings. We talked about very formal things, expectations that weren't really applicable at the time.

I remember that *Con Safos* wanted to charge money for the slides and, where exhibitions were concerned, they were insisting on insurance and stuff like that; at the time that was unheard of. Significant places that wanted to show your work could not afford things like that. But among ourselves, Carlos – especially between myself and Carmen Lomas Garza and Amado Peña – we would look at each other and say, "Well, we keep talking about these things in meetings and we're not showing."

But we needed to exhibit. So we left *Con Safos* and I remember that I wrote a very diplomatic letter why we were leaving. We left the group and we formed *Los Quemados*.

I came up with the name, if I remember correctly. But *Los Quemados* was basically Amado Peña and Carmen Lomas Garza and myself.

We formed a group that was more congenial with our ideas, which were more people- and politically-oriented. Ironically, after that time I think we exhibited once as *Los Quemados*.

JQ: I remember that. Then you went your own ways.

CM: Yes. We were developing individually, and went our own ways. Then we all re-emerged in some of the major shows that started coming up, like *Roots and Visions* and *Dále Gas*.

You know someone that we have not talked about who was very important to all of us was Santos Martínez. He went on to become the curator at the Contemporary Arts Museum in Houston under the directorship of Jim Harithas, who was also a very important character to Texas artists in general. And for Chicanos in particular, very important, because it was through his support and Santos Martínez that *Dále Gas* came about.

JQ: Right.

CM: Santos Martínez is an excellent artist, a very skilled craftsman. He always was drawn more to academics and to curating.

JQ: Well, he could conceptualize certain things and put that exhibition together.

CM: Yes, very committed.

JQ: By the time you met all of these artists, you were essentially going in your own direction. Who had the most impact on you at the time?

CM: I don't think I have mentioned Roberto Ríos at all. Roberto Ríos was a formidable illustrator and commercial artist. I think most of the West Side artists of the time – "Chista," Jesse Almazán, Roberto Ríos, José Esquivel – were commercial artists and they could do virtually anything. Roberto Ríos was a very effective illustrator and his work blew me away.

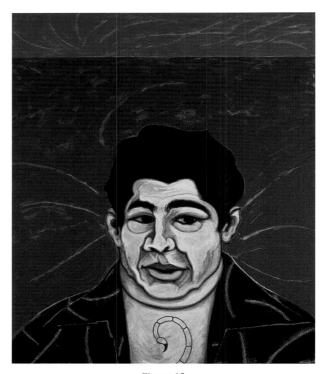

Figure 15
El Alacrán (cat. 19)

He was one hell of a paint handler. His work moved me in a different way: I was just dazzled by the technique and handling of paint.

Another one is José Esquivel. His work was very "down home." He could convey ideas about the barrio, simple stuff, like a quilt hanging on a clothes line but done in a way that is effective.

JQ: But not the people with *Con Safos*? They were part of that too, weren't they?

CM: They were with *Con Safos* at some point, but there were many fallings out and people going in and out again.

Kathy Vargas came in after I was there. I think Rolando Briseño may have been among the last group there that went through *Con Safos*.

JQ: César, how do you think people who have bought your paintings, like the *Bato Series* or the *Pachuco Series*, relate to them if they don't know anything about this.

CM: That's a very interesting question because I don't necessarily have a handle on it, because the acceptance of this series has been so widespread.

It's a universal thing. I think it's crossing into very universal territory there, and I keep wondering, is there "realness" there?

Apparently it has crossed cultures. And things being what they are, it could be that some of the best work has been collected by non-Chicanos, non-Latinos – collectors who collect all kinds of work and then Tejanos.

JQ: Who really just relates to the work?

CM: Who relates to it as art. I think that the work is, of course, very Chicano – consciously. This is about culture and identifiable images.

But I think that our own people tend to look at work like this as a cultural artifact, as opposed to art. They couldn't care less about the background. They go for the character.

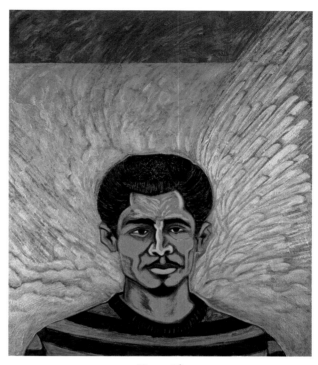

Figure 16
Hombre with a Very Reasonable Dream (cat. 18)

You might think that painting a figure is difficult. Well it is, but the background is a thing in itself, and it has to work.

In both of the pieces that were in the *CARA* show, they cropped the top horizontal band of the images in the catalogue. That's a very crucial part of the painting. I deliberately make my images proportional to the canvas. They're very small in there, because I don't want all of this space around them.

And what influenced that series was the work of Alberto Giacometti.

JQ: Sure.

CM: It's like they carried around them this atmosphere. They look tiny so, in my mind, that's one reason that I have all this space around my figures in most of the work.

It's because I wanted to create this space that is related in some way. It's hard for me to explain this because it's

one of those things that is intuitive and some of the hardest things to do in this series are the backgrounds.

And to those who view these as cultural artifacts, that's irrelevant. To them, it's not a color field.

JQ: Now, did you ever try putting the band of color on the sides? It was always on top? Was it like a horizon?

CM: In most of the work that I have done in this series I painted the figure from the chest up. Sometimes they're placed so low down there is only the neck and the very top of the shoulders. So it's always with that horizontal line there, as a horizon reference line.

JQ: You were never interested in doing the full figure anyway?

CM: I was, but it was just that I've been drawn more to these. Technically, I had my limitations and it's only in

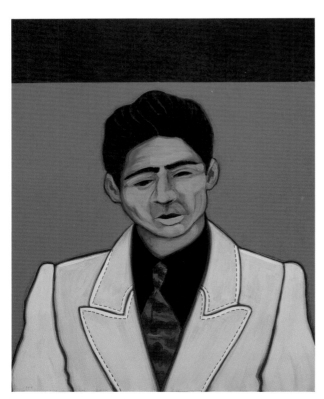

Figure 17
Bato con Pink Jacket (cat. 23)

recent years that I could do a full figure. I mean, it was hard enough putting together just the torso and making it work.

JQ: It's interesting that when Picasso and Braque began to do their experiments in what later became analytical Cubism and then synthetic Cubism that they initially made the full figure when they were essentially decomposing the various parts and creating all these facets, but they evidently found that doing the full figure was too distracting. So, essentially they started doing just the bust and the head.

CM: Yes, they were probably looking for effectiveness. People think that we artists do this stuff easily. I know I don't. I know some artists that are very excellent draftsmen.

I've seen Luis Jiménez work and he's an excellent draftsman. He works in a way that he's constantly correcting himself. It's not like he gets it right the first time. But it becomes part of the whole. And I think Picasso did that to a large extent.

JQ: Did you focus on the torso or bust at the beginning?

CM: The idea of a very frontal, and very emotionless, almost expressionless face just staring at you, that came from Richard Avedon's work. So it was essentially taken from a photographic format. Very neutral. The trick is to do something with that.

JQ: Now, when you do a series of paintings, I guess you're working on them simultaneously?

CM: Yes, because you need to refresh yourself; I mean if you get too much into something, it gets very tight. I am repainting it now until I get what I want and get it right. It should look effortless though nothing is really effortless.

JQ: Could you summarize some of the major approaches that you use in your work?

CM: Maybe I should begin by saying that there has been a progression from when I first started producing work as a professional in the early 1970s to the present. I have continually added themes – general themes, ideas, series of work which have names.

So, I think that as we mentioned before, the very first pieces that I ever exhibited in major exhibitions were those early woodcuts.

They were very individual ideas that I went through great pains to express effectively. Later, my ideas began to come together and I started thinking in terms of series of works. Just about everything has always been there in my mind gestating.

Sometimes it takes years for an idea to become cohesive enough, and for me to find a format for it.

I think [the] *South Texas* [*Series*] took probably over ten years to actually get going.

JQ: Do you think in terms of images or concepts? Or do you scribble things down: "I'm going to do this." Or do you carry a sketchbook around with you?

CM: Well, usually the themes suggest themselves. If I feel there's a visual possibility in a theme, then I start thinking about it - it's always in my mind.

JQ: What is the trigger? When you go down there to visit?

CM: I would say it varies. For example, because art history is very important to me and I have a very good working knowledge of art history as it pertains to me. Sometimes I have an idea and then at some point I'll be going through some of my art books. I'll see some work of art by some other artist and that might trigger an idea of how to approach a subject.

Art history for me is like a Sears and Roebuck catalogue. Sometimes the very subject itself suggests a way.

Some things are best expressed through drawing. In other series, painting becomes more important. In other series, mixed media.

JQ: So, when you get these ideas or a concept, you do sketches?

CM: I have never been a good sketcher or organized sketcher. Probably the best ideas originate as doodles. Then the sketches become more formal, and I start

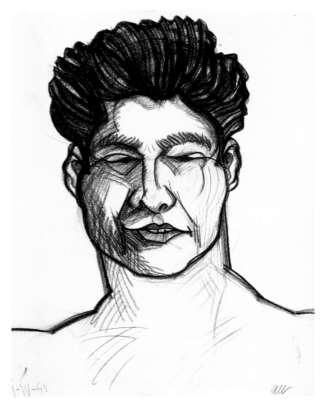

Figure 18
Blind Bato (cat. 62)

narrowing in, but sometimes I'll just be doodling.

JQ: You don't work like a mural painter where you make a sketch and then you do a grid and then you enlarge it?

CM: Well, I do work like that in the final stages. In the *Pachuco Series*, originally my idea was to just start painting on the canvas and let that thing emerge.

I would do a very rough drawing and then refine and refine it until it was done. But as the series evolved, I started paying more attention to drawing.

My own favorite drawing media is charcoal on newsprint, which everybody says, "No, those things are going to deteriorate. The paper is no good." But I'm sorry, it's my favorite paper.

JQ: And it's the right size, too, I guess.

CM: Yes, and it's got just the right texture for charcoal as far as I'm concerned. As you work, everything becomes more systematic – and I think better, although there are those who would say that their first work, the very raw stuff, is better.

I don't think so. I'm not shy about going back to work that is already done and reworking it. I don't actually do a grid because I think that's an antiquated way of transferring an image.

It's very manual. I take a slide of the drawing on paper, regardless of the size. I just compose it on the film, on the camera, and then I project it onto the canvas, and then I can compose photographically.

That goes back to when I was doing a lot of photography. I think that the enlarger is the perfect composing tool.

JQ: But you may know that Siqueiros did that in his murals.

CM: Projected images?

JQ: Yes. He thought that was the thing to do since he was in the 20th century and the last thing he wanted to do was to use the antiquated methods of fresco, which would take forever to prepare. He probably did not have the patience.

CM: Yes, I don't blame him. I might add that sometimes I position those images on the canvas in what seems to the viewer in an awkward position – very low, or maybe awkward. But that's all intentional. But with a projector doing it, you do not make an error.

JQ: Did you ever dream anything that might be used as a source for images? Where does your inspiration come from?

CM: Not from dreams. I dreamed that I had composed an opera and it seemed very original. But I have no musical talent whatsoever. I don't know where that came from. I think I may have had dreams that are related to an upcoming show and I am not ready and I'm worried about that.

JQ: Do you like to go to exhibitions to look at other people's work or have you stayed away from that?

CM: That's an interesting question. I am losing interest in exhibitions now. Contemporary art doesn't do much for me anymore. I'm more into art history.

I used to go to a lot of exhibitions. In regard to what is useful to one as an artist, you'd be surprised at the things that I look at.

Sometimes it's the most banal, commercial work, but I see some possibility there. I think ultimately the substance is in the idea and not in the technique.

JQ: What kind of shows do you gravitate toward?

CM: One of the most memorable was a Norman Rockwell exhibition here at the McNay in the early 1970s. I thought that was wonderful. The technique and everything.

I've seen a couple of Goya shows over the years. It was an experience to see those things, the effectiveness of the work.

JQ: I'd like to go back to the formal aspects of your work; first the composition of the structure.

CM: I think that composition-wise I have a tendency to gravitate to the center of my canvas and I think there's a lot of asymmetry in the work that I do, conscious asymmetry and a centralization of the subjects.

Over the years, I have done a few canvases that go into more of a narrative kind of thing. But those are very rare. There are some canvases that have more complex compositions.

By saying "more complex," I'm not implying that maybe there's something lacking there. I don't think that complexity is necessarily better. I pare down my ideas.

My initial impulse usually is to throw everything in, and then once I start working, I start throwing out a lot of things because I realize that they do nothing for conveying the idea.

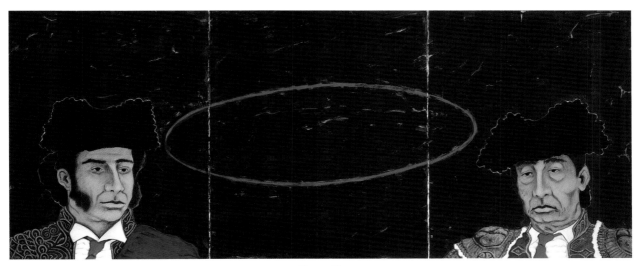

Figure 19
Tauromaquia Triptych (cat. 51)

JQ: Why do you think in the *South Texas Series* when there's so much going on visually with the various materials, that you're more apt to deal with structural problems or you have the asymmetry?

CM: Probably because I'm dealing with many sub-themes. First of all, there's the biographical, in the sense that this is about where I grew up. And then there's also undercurrents of ecological themes. For example, in the *South Texas Series*, some work deals with what in other places would be called deforestation. Here it's called brush clearing. The interesting thing is that here the brush renews itself even faster and comes on stronger after you eradicate it. I think South Texas is a very tough land, the climate is very tough, very hot, very dry.

I think it's harsh and I think that somewhere in there is a larger metaphor for survival, of how people and animals and plants adapt to a certain area and survive.

JQ: Let's concentrate on the content and how you deal with that. I'd like to start with the color-field paintings and the related *Serape Series*.

CM: Well, not a precursor but based specifically on the work of the painter who used a stripe-painting format.

Gene Davis, an artist from Washington, D.C. I saw those when I was in college. And I saw them for what they were; my cultural mind was reading them as serapes. And I think you might even say that that's one of the first times that I started thinking culturally. That was like a transitional series. I went from that into the *Pachuco Series*.

JQ: Now, when you started thinking of the pre-Columbian things, what sources did you use for that?

CM: Manuel Hernández really impressed me because he was doing a take-off on pre-Columbian work but he was doing some very regional things with it.

I was also very close to Amado [Peña] at that time and we used to exchange a lot of work also.

JQ: What part of the pre-Columbian material attracted you? The stamps?

CM: Yes, it was the stamps. And you might say it was secondhand, because it wasn't even the actual

thing. It was that book that everybody used, that little paperback.

JQ: By a man named Enciso. They were actually designs taken from mainly Central Mexico.

CM: I think they were cylindrical things that you could impress on something.

JQ: Exactly. They were the equivalent of the woodcut but made out of clay.

CM: Yes, and cylindrical so that you would roll it and then the image would repeat itself as you rolled it.

JQ: Can we talk a bit about the *Mestizo Series*? You make references to Spain and Mexico, with the jaguar referring to Mexico and the bull to Spain.

CM: I think it emerged in the mid-1980s, and was basically a response to something that had always bothered me about the work that we were doing – the Chicano art, in general – in that there was a tendency to deprecate the European side of us. But I felt that was a very uninformed reaction. Here we also had the Aztecs, who were supposedly oppressed but they weren't exactly benevolent rulers themselves. I admired aspects of both cultures and that became the *Mestizo Series*. We are Mestizos.

And I think that another reason that I have been sympathetic to Spanish culture is because my first ambition was to be a bullfighter.

JQ: Really?

CM: Some people don't believe it, but I was very serious and I'm still obsessed with it. I had to learn everything as an artist. It did not come naturally. At times, I think I would trade in all I have accomplished to be a bullfighter.

JQ: Well, when did you see your first bull fight?

CM: The first one that I saw, I was scared stiff. I thought the horses were going to get killed. They actually do

sometimes, at least by accident. They're well-padded, well-protected. I was a kid in Nuevo Laredo.

And I saw a book about Manolete, and from that moment, that's all I thought about. It's also a culture unto itself and it has its own music and its own way of talking, even its own way of walking. I took up training with *Novilleros* in Nuevo Laredo, we would actually go to bull breeding ranches and practice with real fighting animals, not bulls but young females. This passion made me conscious of another culture.

JQ: Let's talk about themes that cut across series, such as *Virgen de Guadalupe*, starting with the earliest of your works in woodcut.

CM: One of the most striking images that emerged from the woodcuts was a piece called *Dando Vida*. It was a woodcut where basically I had seen a picture of a semi-mummified, semi-skeletal human remains in a fetal position from a burial of some Indians or indigenous people in South America.

I think it encapsulated many different cultural bases, ecological bases. Basically that was my ecological statement. I gave it a cultural context. It was basically about how you die and if you were buried in your natural state without chemicals or anything, you decompose and become nutrients for the earth itself.

It's my version of pushing up the daisies. There is a tree near where I grew up in Laredo – when I die I would like to have my ashes put there.

JQ: There's the myth of Quetzalcoatl, who brings life from the skeletal remains in the underworld.

CM: Yes, I think I had conversations like that with "Chista." "Chista" was very much into pre-Columbian art. It was one of the first images of mine that was widely published in magazines and reviews of that particular show, *Ancient Roots/New Visions*.

It was in the woodcuts that the Don Pedrito figure first emerged. It would reemerge in the *South Texas Series*.

JQ: Can you talk a little bit about your experience with Don Pedrito. Obviously you had heard of him when you were growing up?

CM: Yes, I know generally the history of Don Pedrito. Don Pedrito was a man from Jalisco or the Guadalajara area of Mexico. He was a *campesino*. One time he was riding on his horse and he got hit right on the face, the nose, to be specific, by a branch. And he fell off unconscious from the horse and when he woke up, he had this terrible gash on his nose.

I believe the story goes that there was a small pond and he rubbed some mud on the wound and – he got well and maybe he had some kind of religious experience there and he felt like he had some kind of power to cure. Eventually he migrated to South Texas. And in what is now Falfurrias, a little place called "Los Olmos," a little ranch out there became a local legend. People from far, far away, both Mexicans and Anglos, would come to him for remedies or to cure some ill. He became part of the folk history of South Texas at the turn of the century.

JQ: Can we continue to discuss two key works from the *Bato Series*?

CM: Okay. One of those early key works was a piece called *Bato Con Sunglasses* and I eventually did a lot of versions of that.

JQ: You did a print of that.

CM: A couple of prints. So, anyway, talk about overdoing a subject. But it was good material. So, I couldn't help myself. I intend to do it again. I personally affected sunglasses because it was kind of cool to wear sunglasses. So, that piece was a very effective piece and pivotal.

Another piece was a fairly faithful portrait of another friend who went to school with me, elementary through high school. His name was Baltazar López.

Pictorially, it was pivotal because of the color relationships. I use combinations of colors there that I thought were odd. And I felt that it worked.

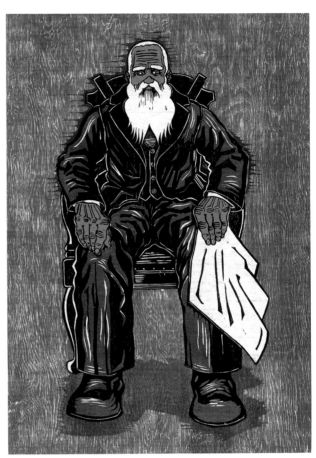

Figure 20
Don Pedrito Jaramillo (cat. 77)

JQ: Can you discuss the role of religion in your work?

CM: I was born a Catholic. And for years, I was kind of hostile to the idea of religion.

But I became reconciled. I realize that it's a cultural thing also. And culture is important to me. So I reconciled myself to the fact that religion is there whether I believe or not. I decided to do works that were not disrespectful, but added my own perceptions; for example, about the *Virgen de Guadalupe*. Introducing elements that had not been used before. I started doing them in the form of crucifixes.

But, again, I was going into the Mestizo thing where all of the pre-Columbian as well as more current elements arose.

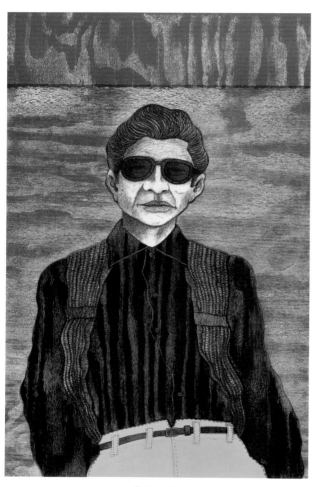

Figure 21
El Pantalón Rosa (cat. 83)

JQ: Can you describe the role of the *Virgen de Guadalupe* in your work?

CM: Yes, that image lingered in my mind for a while. But the origins of the Mona Lupe was basically derived from the Leonardo da Vinci portrait with La Gioconda dressed in *Virgen de Guadalupe* drag.

I have my own theory about how this whole thing evolved and I have tried to read as much as I could. Many Chicano artists have used her image and she is definitely an important icon. It is interesting to see the various interpretations among both Mexican and Spanish artists.

JQ: How does cultural imagery and politics reconcile itself in your work?

CM: Even though I have never claimed to be a political artist, to me culture has always been an underpinning and the thing that unites us, regardless of different political ideologies. Since I have been a professional artist, cultural references have been an interesting tool to use and have had to do with those things that resulted from the Chicano movement. Art was certainly a supportive arm of the movement. I think there is much more metaphorical material that goes beyond the specific, putting it on a universal plane.

Checklist of the Exhibition

PAINTINGS AND CONSTRUCTIONS

Batos and Pachucos

1.
Bato con Sunglasses Spring 1978
acrylic on canvas
36 x 24 in.
Collection of the artist
Figure 3

2.
Chavo con Gafas March 11, 1978
acrylic on canvas
66 x 44 in.
Collection of Emma L. Mendiola, San Antonio
Plate 1

3.
Screaming Bato March 16, 1978
acrylic on canvas
24 x 18 in.
Collection of the artist
Figure 4

4.
La Parot September 12, 1979
acrylic on canvas
70 x 50 in.
Collection of Joe A. Diaz, San Antonio
Plate 2

5.
Veterano September 13, 1982
acrylic on canvas
47 x 40 in.
Collection of Ann and James Harithas, Houston
Figure 12

6.
El Pantalón Rosa March 7, 1984
acrylic on canvas
60 x 50 in.
Collection of Bernard Lifshutz, San Antonio
Plate 3

7.
Azul Azul December 1, 1984
acrylic on canvas
47 x 40 in.
Collection of María Elena Martínez, Austin
Plate 4

8.
Hombre Que le Gustan las Mujeres March 26, 1985
acrylic on canvas
50 x 44 in.
Collection of Lewis Dickson, Esq., Houston
Plate 5

9.
El Enano White June 13, 1985
acrylic on canvas
64 x 54 in.
Collection of Joe A. Diaz, San Antonio
Plate 6

10.
La Fulana (The Other Woman) June 16, 1985
acrylic on canvas
70 x 60 in.
Collection of Joe A. Diaz, San Antonio
Plate 7

11.
Bato con Highschool Jacket 1986
acrylic on canvas
64 x 54 in.
Collection of the San Antonio Museum of Art, San Antonio
Purchased with Tom Slick Estate Acquisition Funds
Plate 8

12.
El Güero March 11, 1987
acrylic on canvas
54 x 44 in.
Collection of Cheech Marin, Los Angeles
Plate 9

13.
Bato con Sunglasses 1988
acrylic on canvas
74 x 54 in.
Collection of Janie and Dick DeGuerin, Houston
Plate 10

14.
Bato con Angst August 15, 1989
acrylic on canvas
28 x 24 in.
Collection of Maria and Roberto Treviño, San Antonio
Plate 11

15.
El Gato August 24, 1989
acrylic on canvas
54 x 64 in.
Collection of Joe A. Diaz, San Antonio
Plate 12

16.
Batito con Smirk September 12, 1989
acrylic on canvas
64 x 54 in.
Collection of Michele and Alan Skupp,
Livingston, New Jersey
Plate 13

17.
Wrong-Headed Hombre September 24, 1989
acrylic on canvas
54 x 64 in.
Collection of Lewis Dickson, Esq., Houston
Plate 14

18.
Hombre with a Very Reasonable Dream
August 6, 1990
acrylic on canvas
40 x 34 in.
Collection of Joe A. Diaz, San Antonio
Figure 16

19.
El Alacrán September 24, 1990
acrylic on canvas
40 x 34 in.
Collection of Joe A. Diaz, San Antonio
Figure 15

20.
Worried Bato September 28, 1990
acrylic on canvas
40 x 34 in.
Collection of Joe A. Diaz, San Antonio
Plate 15

21.
Mujer con Big Hair February 20, 1992
acrylic on canvas
54 x 44 in.
Collection of Janie and Dick DeGuerin, Houston
Plate 16

22.
Beto la Momia April 26, 1993
acrylic on canvas
74 x 54 in.
Courtesy of the artist
Plate 17

23.
Bato con Pink Jacket February 11, 1994
acrylic on masonite
22 x 18 in.
Courtesy of MD MODERN, Houston
Figure 17

24.
Fulana (The Other Woman) April 6, 1996
acrylic on canvas
64 x 52 in.
Courtesy of MD MODERN, Houston
Plate 18

25.
El Mazo con Football Jacket August 29, 1997
oil on canvas
64 x 64 in.
Courtesy of Parchman-Stremmel Gallery, San Antonio
Plate 19

26.
La Chata September 2, 1997
oil on canvas
64 x 54 in.
Collection of Guillermo Nicolas, San Antonio
Plate 20

Serape Series
27.
Work from the *Serape Series* November 22, 1980
acrylic on paper
14 1/4 x 27 1/2 in.
Courtesy of the artist
not illustrated

28.
Work from the *Serape Series* July 7, 1981
acrylic on paper
14 1/4 x 27 1/2 in.
Courtesy of the artist
not illustrated

29.
Flores Para los Muertos October 3, 1981
acrylic on canvas
50 x 50 in.
Courtesy of the artist
not illustrated

30.
Flores Para los Muertos November 30, 1983
acrylic on canvas
50 x 50 in.
Courtesy of the artist
Figure 2

31.
Tauromaquia February 4, 1984
acrylic on canvas
50 x 50 in.
Courtesy of the artist
Plate 21

South Texas Series

32.
Amor a la Tierra (en el Sur de Tejas) June 27, 1989
acrylic on metal sign
11 x 14 in.
Collection of the artist
Figure 6

33.
South Texas Schism December 17, 1989
mixed media on paper
22 x 30 in.
Collection of the artist
Figure 13

34.
Forma Goyesca Sobre la Tierra de las Espinas
January 11, 1990
acrylic on metal and wood
9 x 11 in.
Collection of the artist
Figure 5

35.
Turmoil in South Texas February 24, 1990
mixed media on canvas and corrugated metal
40 x 34 in.
Collection of Pablo Alvarado, Dallas
Plate 22

36.
Forma Goyesca Sobre la Velada de los Refugiados
May 19, 1990
mixed media on metal and wood
24 3/4 x 18 3/4 in.
Collection of Mary Ann Smothers Bruni, San Antonio
Plate 23

37.
Remembering a Dead Snake in South Texas
November 26, 1990
mixed media on metal and wood
24 3/4 x 42 3/4 in.
Courtesy of the artist
Plate 24

38.
El Señor de los Milagros February 13, 1991
mixed media on metal and wood
24 3/4 x 42 3/4 in.
Courtesy of the artist
Plate 25

39.
Sol y Remolino March 4, 1992
mixed media on canvas
64 x 64 in.
Collection of Robert L. B. Tobin, San Antonio
Plate 26

40.
Flor con Forma Goyesca (Matando la Onda)
June 2, 1992
acrylic and wood on masonite
12 x 12 in.
Collection of Bruno Andrade, Corpus Christi
Plate 27

41.
Flor Innocente August 12, 1992
acrylic on paper
6 x 10 in.
Collection of the artist
not illustrated

42.
Parece Que Viene Agua (Looks Like Rain)
September 7, 1992
mixed media on wood and metal
25 x 34 in.
Collection of Adela G. Martínez, Laredo
Plate 28

43.
The Scream in South Texas (La Llorona)
December 28, 1992
mixed media on metal and wood
24 3/4 x 42 3/4 in.
Courtesy of MD MODERN, Houston
Plate 29

44.
Remolino Coloso (For/After Goya) February 18, 1993
acrylic on canvas
63 1/4 x 74 in.
Courtesy of Parchman-Stremmel Gallery, San Antonio
Plate 30

45.
Cono's Christmas Buck (South Texas Lascaux)
July 1993
mixed media and metal on wood
64 x 64 in.
Collection of Robert L. B. Tobin, San Antonio
Plate 31

46.
Found Landscape with Remolino July 1993
mixed media on wood
64 x 64 in.
Collection of Robert L. B. Tobin, San Antonio
Plate 32

47.
Volcán April 18, 1994
acrylic and mixed media on masonite
14 x 14 in.
Courtesy of the artist
not illustrated

48.
Death of Innocence May 16, 1994
acrylic and charcoal on canvas
55 1/2 x 45 1/2 in.
Collection of the El Paso Museum of Art, El Paso
Robert U. and Mabel O. Lipscomb Foundation
Endowment Purchase
Plate 33

49.
Soñando con los Angelitos November 14, 1994
mixed media on wood
74 x 64 in.
Courtesy of the artist
Plate 34

50.
El Tiempo Borra Todo I-IV June 11-17, 1998
mixed media on canvas
series of 4, each 22 3/4 x 22 3/4 in.
Courtesy of the artist
Plate 35

Mestizo Series

51.
Tauromaquia Triptych November 1986
acrylic on paper
30 x 67 1/2 in.
Collection of Lewis Dickson, Esq., Houston
Figure 19

52.
Europa August 24, 1989
acrylic on paper
41 x 29 in.
Collection of Lewis Dickson, Esq., Houston
Plate 36

53.
Mona Lupe: The Epitome of Chicano Art
January 15, 1991
acrylic on canvas
28 1/8 x 20 1/4 in.
Collection of Alfredo Cisneros, Elburn, Illinois
Figure 7

54.
Reinvented Icon for this Time and Place (San Antonio)
June 3, 1991
mixed media on masonite
30 3/4 x 50 1/2 in.
Courtesy of the artist
Plate 37

55.
Quinto Sol: Cruz Mestiza June 30, 1992
mixed media on car hood and corrugated metal
48 x 88 in.
Collection of Nancy and Charles Kaffie, Corpus Christi
Plate 38

DRAWINGS AND WATERCOLORS

Batos and Pachucos

56.
Mujer in 1950s Pose May 1, 1980
mixed media on paper
26 x 19 in.
Collection of Joe A. Diaz, San Antonio
Plate 39

57.
1940s Style: UFO and Pachuco June 11, 1981
mixed media on paper
26 x 19 in.
Courtesy of the artist
Figure 11

58.
Bato con Khakis April 8, 1982
watercolor and crayon on paper
18 1/2 x 12 in.
Collection of Joe A. Diaz, San Antonio
Plate 40

59.
Low Rider Bizco July 8, 1984
mixed media on paper
30 x 22 in
Collection of Bromley Aguilar + Associates, San Antonio
Figure 14

60.
A Man and His Dreamgirl October 1, 1990
mixed media on paper
24 x 18 in.
Collection of Joe A. Diaz, San Antonio
Plate 41

61.
1940s Prim October 1, 1990
mixed media on paper
24 x 18 in.
Courtesy of the artist
not illustrated

62.
Blind Bato April 21, 1991
charcoal on paper
22 x 18 in.
Courtesy of the artist
Figure 18

63.
Bato con Sunglasses February 4, 1994
graphite on paper
24 x 18 in.
Courtesy of the artist
not illustrated

Mestizo Series

64.
Shadowy Figures (After Goya) December 11, 1986
charcoal on paper
30 x 45 in.
Collection of the artist
Plate 42

65.
Palma de Nuevo León May 25, 1987
charcoal and pastel on paper
41 x 29 in.
Courtesy of the artist
not illustrated

66.
El Mestizo June 11, 1987
charcoal and pastel on paper
29 x 41 in.
Courtesy of the artist
Plate 43

67.
La Luz y el Toro July 5, 1989
watercolor on paper
7 x 10 in.
Courtesy of the artist
not illustrated

68.
Europa October 6, 1990
charcoal and watercolor on paper
41 x 29 in.
Courtesy of the artist
Plate 44

69.
Las Américas October 6, 1990
charcoal and watercolor on paper
41 x 29 in.
Courtesy of the artist
Figure 8

PRINTS

70.
Tranquilidad del Vato Quemado 1975
woodcut
11 1/2 x 16 1/2 in.
Collection of the artist
Figure 9

71.
Dando Vida 1975
hand-colored woodcut
18 1/4 x 11 1/2 in.
Collection of Carlos Guerra, San Antonio
Figure 1

72.
Vacilando 1975
hand-colored woodcut
10 x 15 1/4 in.
Courtesy of the artist
Figure 10

73.
Liberación 1975
woodcut
20 1/2 x 11 1/2 in.
Courtesy of the artist
Plate 45

74.
Peyotl 1976
hand-colored woodcut
16 1/2 x 9 1/2 in
Courtesy of the artist
Plate 46

75.
Brujerías 1976
woodcut
11 1/2 x 12 in.
Courtesy of the artist
not illustrated

76.
Don Pedrito Jaramillo 1976
woodcut
16 1/2 x 11 1/2 in.
Courtesy of the artist
Plate 47

77.
Don Pedrito Jaramillo 1976
woodcut
26 x 17 in.
Collection of the artist
Figure 20

78.
Bato con Sunglasses 1981
linocut
11 3/4 x 9 in.
Collection of Joe A. Diaz, San Antonio
not illustrated

79.
Bato Azul June 25, 1985
monotype
27 x 20 1/2 in.
Courtesy of the artist
Plate 48

80.
Bato Rojo November 7, 1988
linocut
9 3/4 x 7 3/4 in.
Collection of Joe A. Diaz, San Antonio
Plate 49

81.
Calavera Torera September 18, 1990
linocut with watercolor on paper
30 x 22 in.
Courtesy of the artist
Plate 50

82.
Bato Que le Gustan las Mujeres 1992
lithograph
34 x 28 in.
Collection of Joe A. Diaz, San Antonio
not illustrated

83.
El Pantalón Rosa 1992
lithograph
35 x 23 in.
Collection of Joe A. Diaz, San Antonio
Figure 21

84.
Pirámide con Cruz y Toro #2 July 25, 1995
screenprint
16 x 16 in.
Collection of Joe A. Diaz, San Antonio
Plate 51

85.
ArtPace 97.3 Monotype #9 May-July 1997
monotype
22 3/8 x 22 3/8 in.
Courtesy of the artist
not illustrated

86.
ArtPace 97.3 Monotype #15 May-July 1997
monotype
22 3/8 x 22 3/8 in.
Collection of Pat and Bud Smothers, San Antonio
Plate 52

87.
ArtPace 97.3 Monotype #44 May-July 1997
monotype
22 3/8 x 22 3/8 in.
Courtesy of the artist
not illustrated

88.
ArtPace 97.3 Nike de San Anto Monotype #3
August 1997
monotype
34 x 30 in.
Courtesy of the artist
Plate 53

89.
Dando Vida 1999
linocut and lithograph
30 x 22 in.
Courtesy of Hare and Hound Press, San Antonio
Plate 54

COLOR PLATES

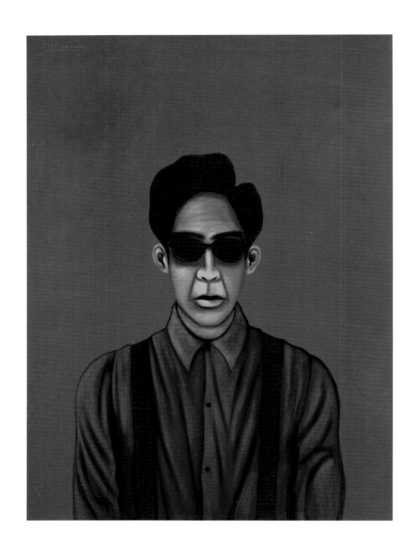

Plate 1
Catalogue 2
Chavo con Gafas March 11, 1978
acrylic on canvas
Collection of Emma L. Mendiola, San Antonio

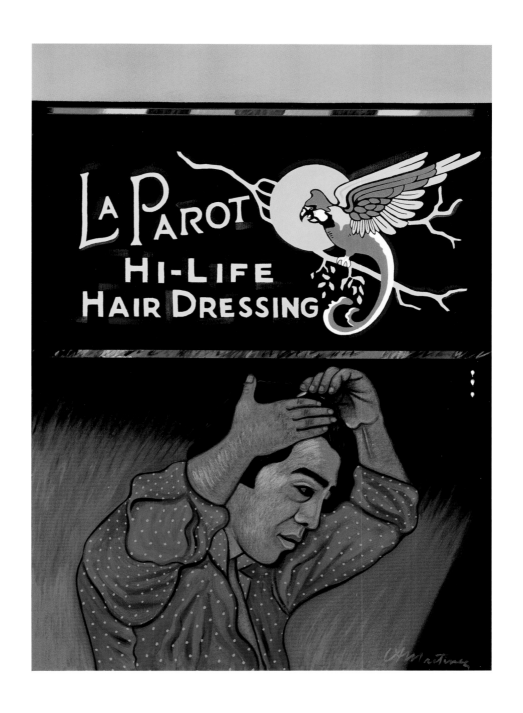

Plate 2
Catalogue 4
La Parot September 12, 1979
acrylic on canvas
Collection of Joe A. Diaz, San Antonio

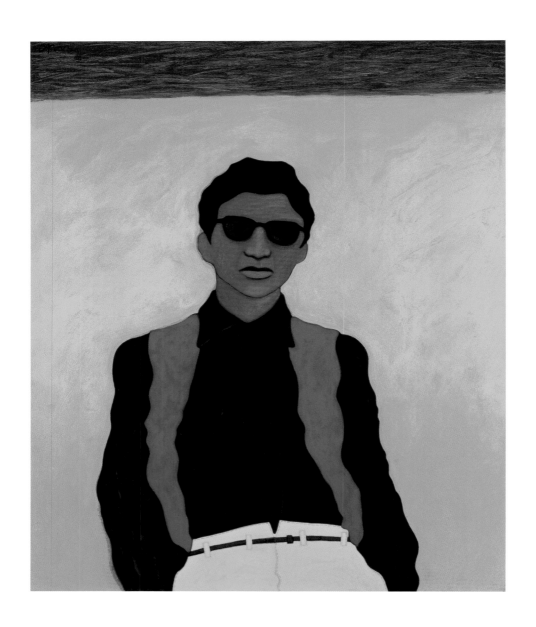

Plate 3
Catalogue 6
El Pantalón Rosa March 7, 1984
acrylic on canvas
Collection of Bernard Lifshutz, San Antonio

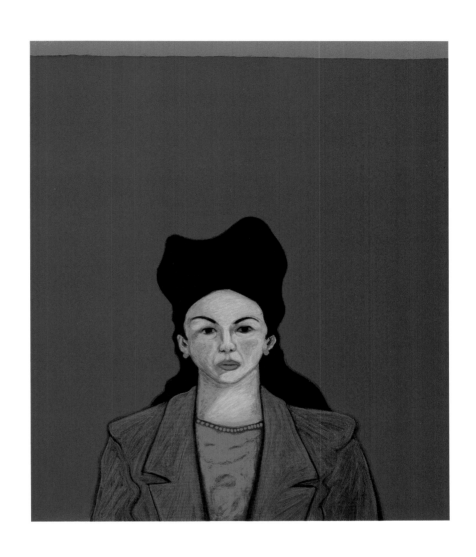

Plate 4
Catalogue 7
Azul Azul December 1, 1984
acrylic on canvas
Collection of María Elena Martínez, Austin

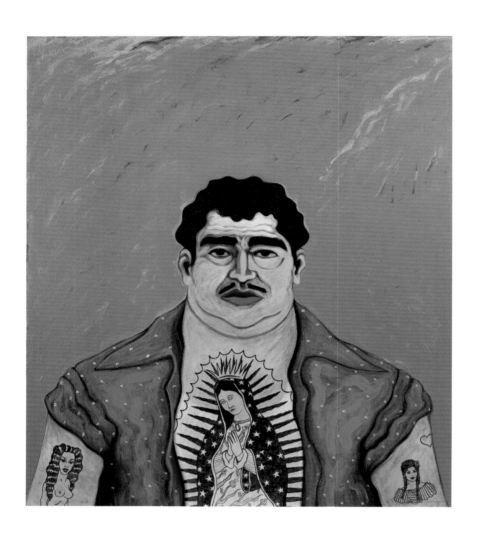

Plate 5
Catalogue 8
Hombre Que le Gustan las Mujeres March 26, 1985
acrylic on canvas
Collection of Lewis Dickson, Esq., Houston

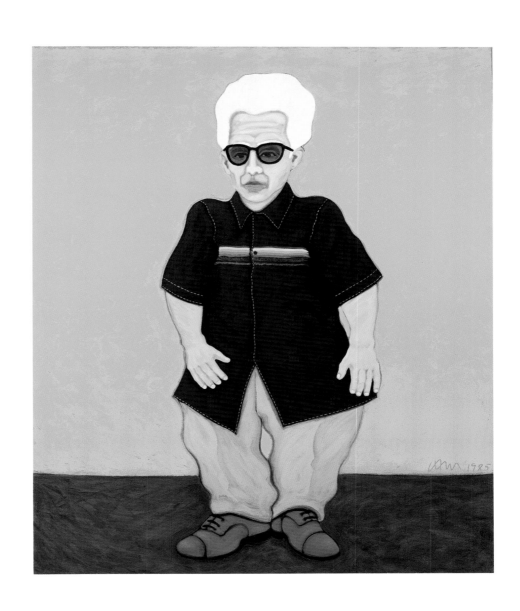

Plate 6
Catalogue 9
El Enano White June 13, 1985
acrylic on canvas
Collection of Joe A. Diaz, San Antonio

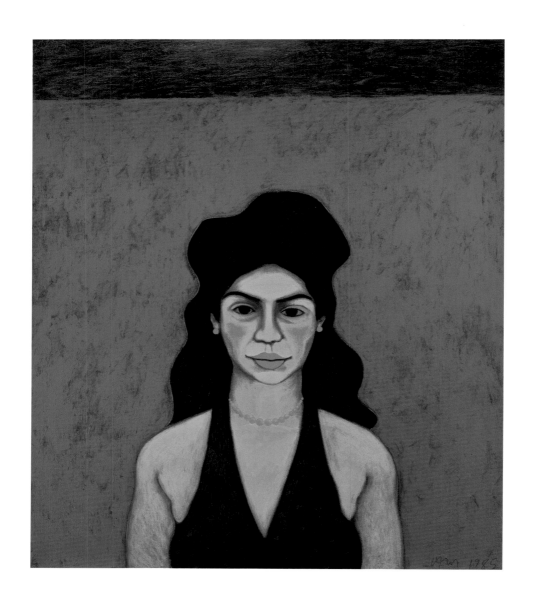

Plate 7
Catalogue 10
La Fulana (The Other Woman) June 16, 1985
acrylic on canvas
Collection of Joe A. Diaz, San Antonio

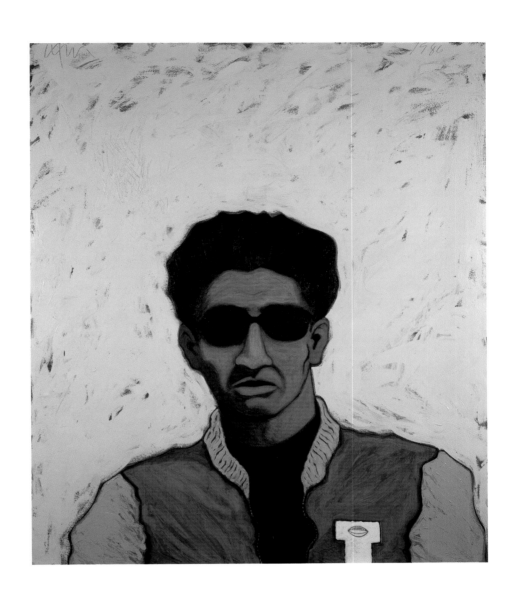

Plate 8
Catalogue 11
Bato con Highschool Jacket 1986
acrylic on canvas
Collection of the San Antonio Museum of Art,
Purchased with Tom Slick Estate Acquisition Funds

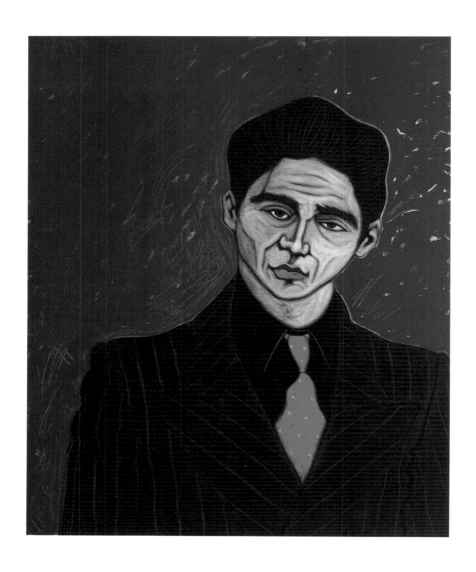

Plate 9
Catalogue 12
El Güero March 11, 1987
acrylic on canvas
Collection of Cheech Marin, Los Angeles

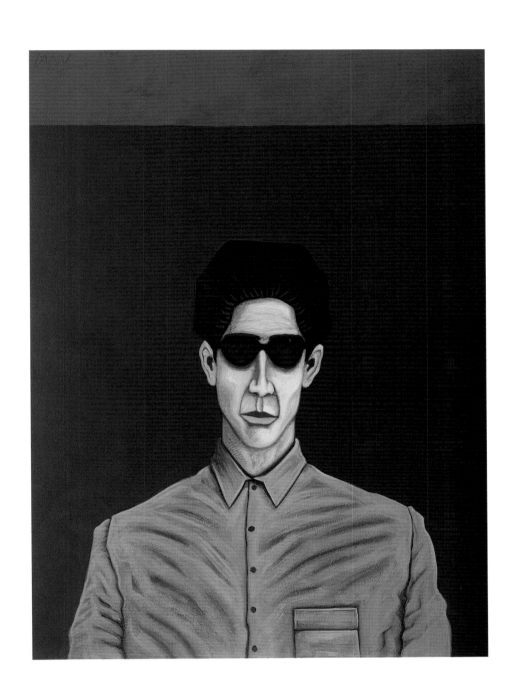

Plate 10
Catalogue 13
Bato con Sunglasses 1988
acrylic on canvas
Collection of Janie and Dick DeGuerin, Houston

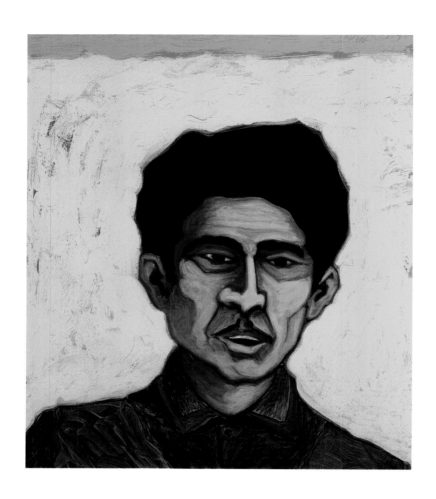

Plate 11
Catalogue 14
Bato con Angst August 15, 1989
acrylic on canvas
Collection of Maria and Roberto Treviño, San Antonio

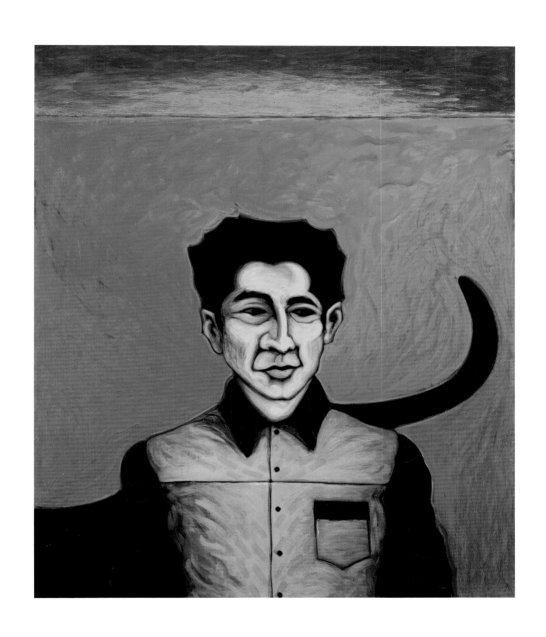

Plate 12
Catalogue 15
El Gato August 24, 1989
acrylic on canvas
Collection of Joe A. Diaz, San Antonio

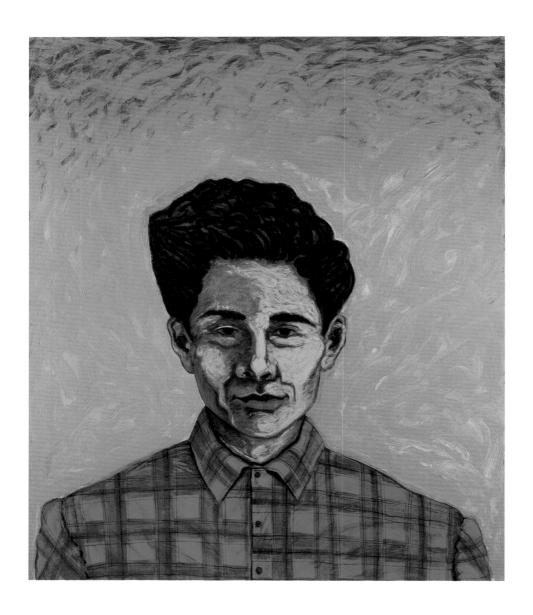

Plate 13
Catalogue 16
Batito con Smirk September 12, 1989
acrylic on canvas
Collection of Michele and Alan Skupp, Livingston, New Jersey

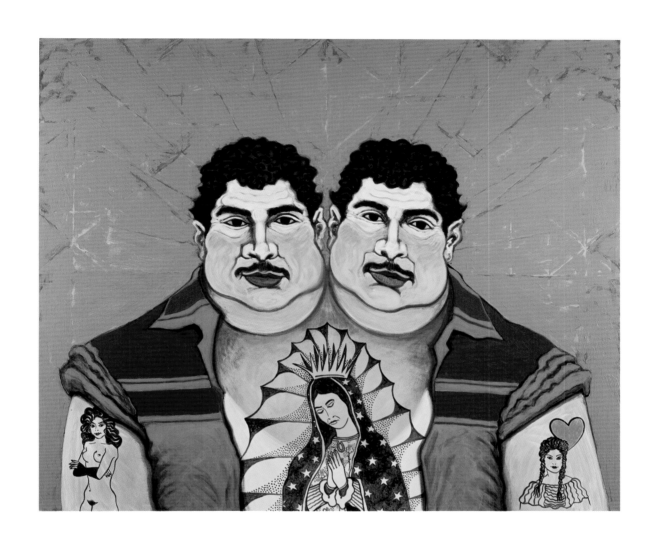

Plate 14
Catalogue 17
Wrong-Headed Hombre September 24, 1989
acrylic on canvas
Collection of Lewis Dickson, Esq., Houston

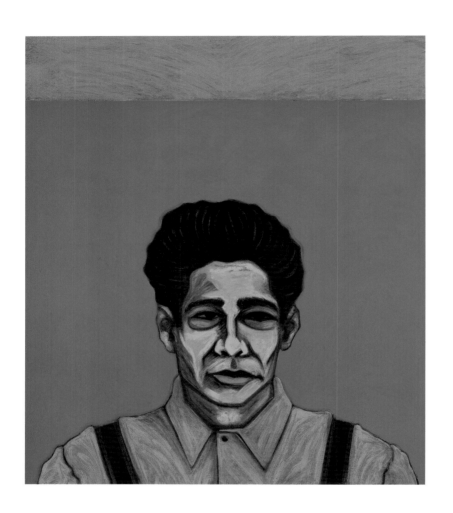

Plate 15
Catalogue 20
Worried Bato September 28, 1990
acrylic on canvas
Collection of Joe A. Diaz, San Antonio

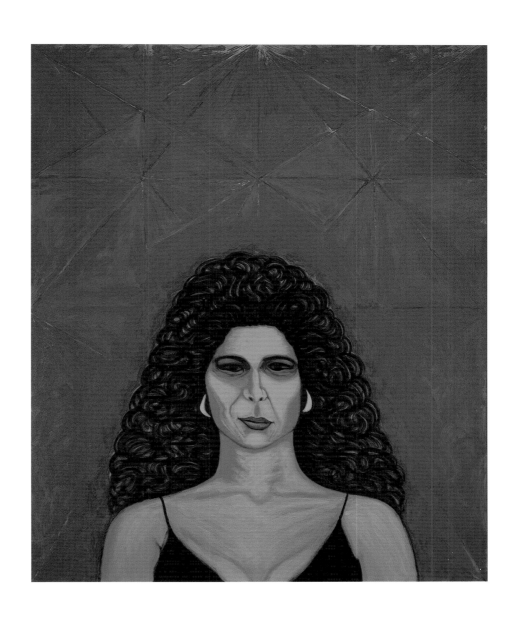

Plate 16
Catalogue 21
Mujer con Big Hair February 20, 1992
acrylic on canvas
Collection of Janie and Dick DeGuerin, Houston

Plate 17
Catalogue 22
Beto la Momia April 26, 1993
acrylic on canvas
Courtesy of the artist

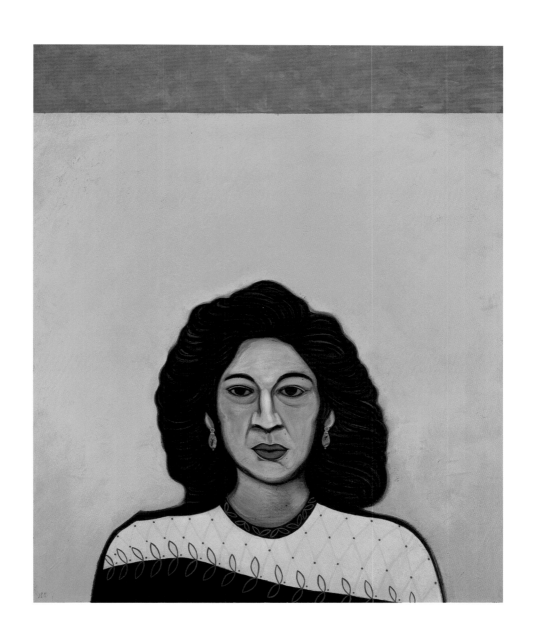

Plate 18
Catalogue 24
Fulana (The Other Woman) April 6, 1996
acrylic on canvas
Courtesy of MD MODERN, Houston

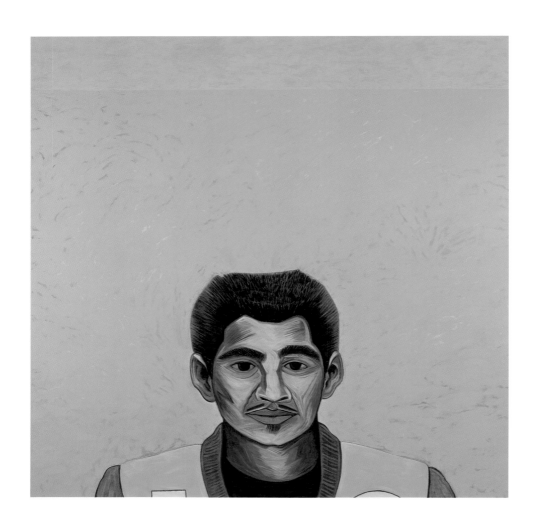

Plate 19
Catalogue 25
El Mazo con Football Jacket August 29, 1997
oil on canvas
Courtesy of Parchman-Stremmel Gallery, San Antonio

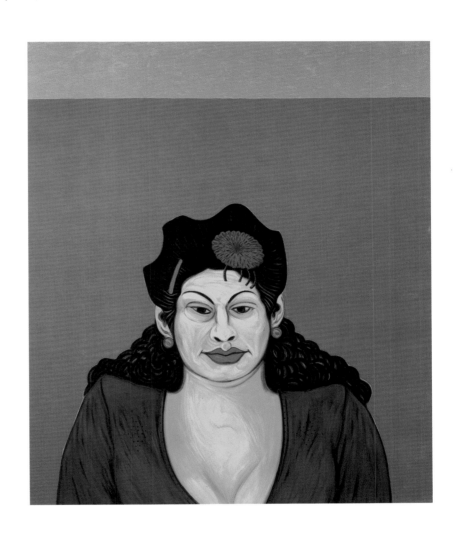

Plate 20
Catalogue 26
La Chata September 2, 1997
oil on canvas
Collection of Guillermo Nicolas, San Antonio

Plate 21
Catalogue 31
Tauromaquia February 4, 1984
acrylic on canvas
Courtesy of the artist

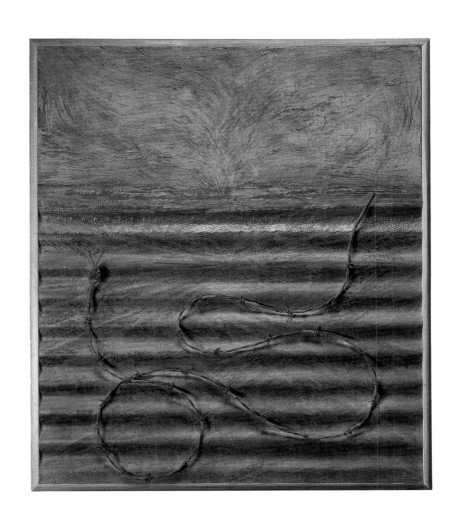

Plate 22
Catalogue 35
Turmoil in South Texas February 24, 1990
mixed media on canvas and corrugated metal
Collection of Pablo Alvarado, Dallas

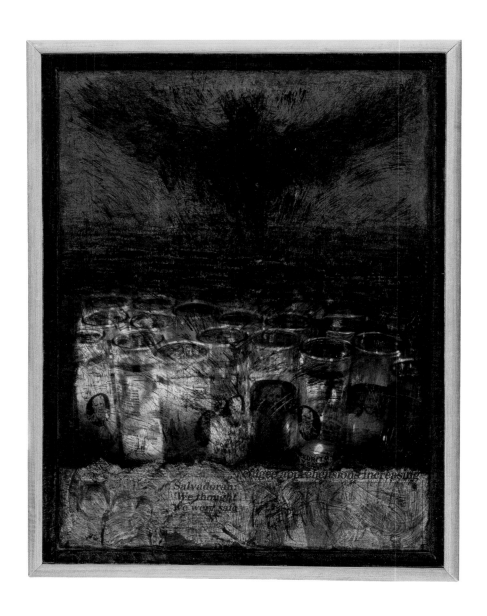

Plate 23
Catalogue 36
Forma Goyesca Sobre la Velada de los Refugiados May 19, 1990
mixed media on metal and wood
Collection of Mary Ann Smothers Bruni, San Antonio

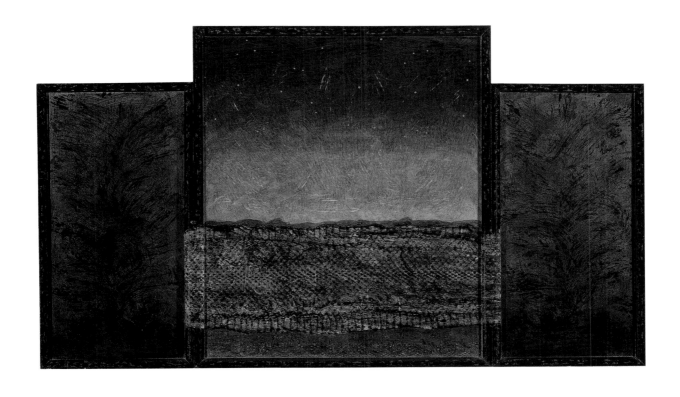

Plate 24
Catalogue 37
Remembering a Dead Snake in South Texas November 26, 1990
mixed media on metal and wood
Courtesy of the artist

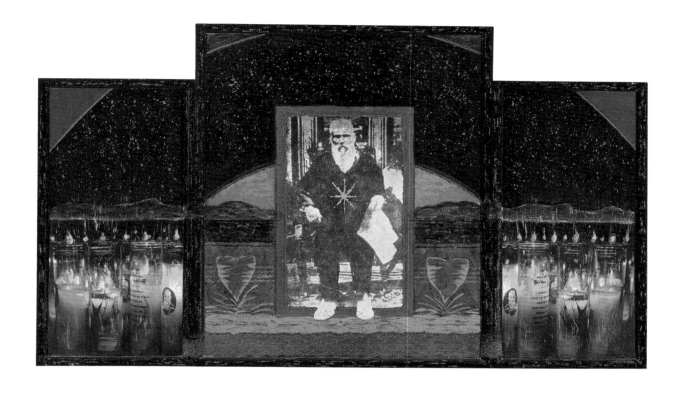

Plate 25
Catalogue 38
El Señor de los Milagros February 13, 1991
mixed media on metal and wood
Courtesy of the artist

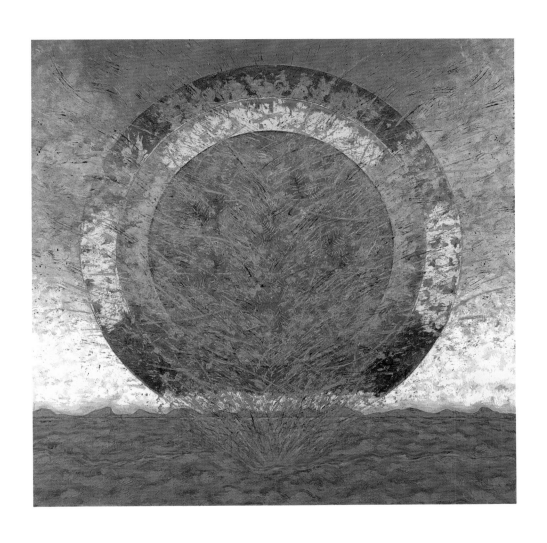

Plate 26
Catalogue 39
Sol y Remolino March 4, 1992
mixed media on canvas
Collection of Robert L. B. Tobin, San Antonio

69

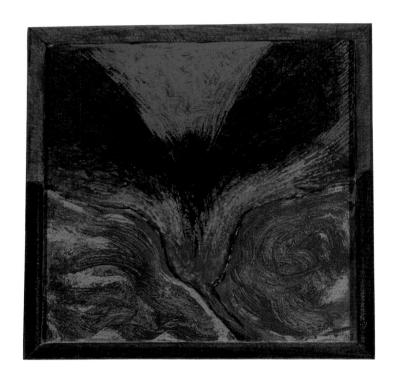

Plate 27
Catalogue 40
Flor con Forma Goyesca (Matando la Onda) June 2, 1992
acrylic and wood on masonite
Collection of Bruno Andrade, Corpus Christi

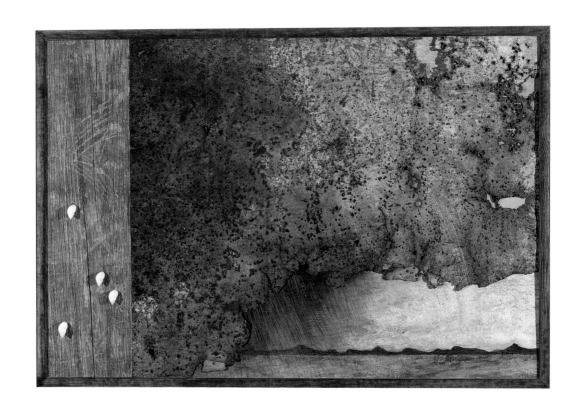

Plate 28
Catalogue 42
Parece Que Viene Agua (Looks Like Rain) September 7, 1992
mixed media on wood and metal
Collection of Adela G. Martínez, Laredo

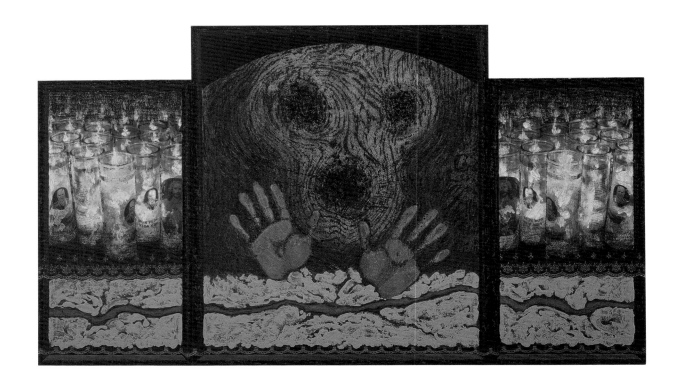

Plate 29
Catalogue 43
The Scream in South Texas (La Llorona) December 28, 1992
mixed media on metal and wood
Courtesy of MD MODERN, Houston

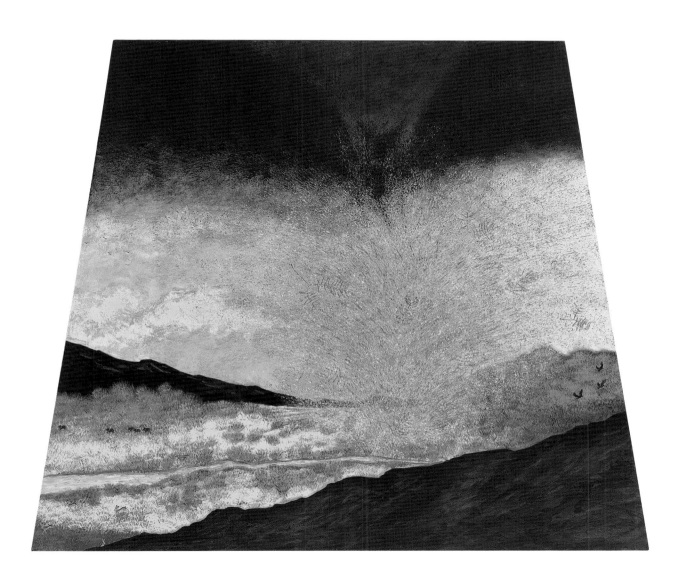

Plate 30
Catalogue 44
Remolino Coloso (For/After Goya) February 18, 1993
acrylic on canvas
Courtesy of Parchman-Stremmel Gallery, San Antonio

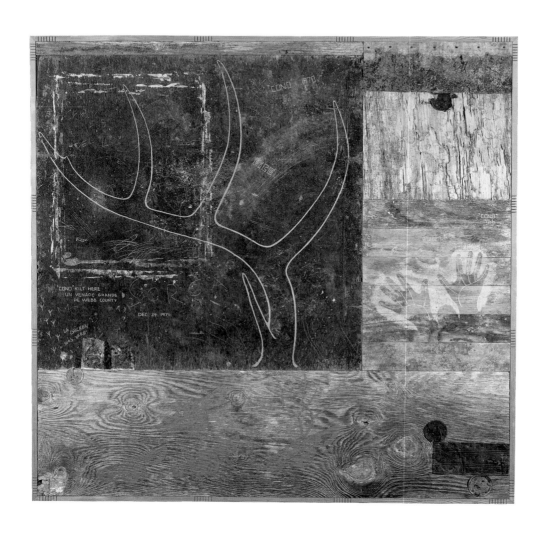

Plate 31
Catalogue 45
Cono's Christmas Buck (South Texas Lascaux) July 1993
mixed media and metal on wood
Collection of Robert L. B. Tobin, San Antonio

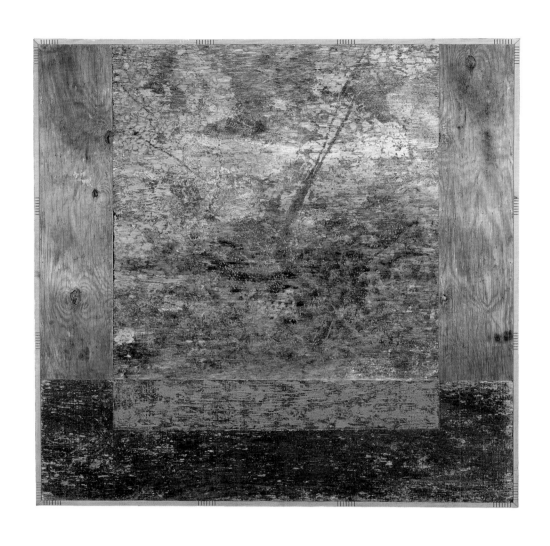

Plate 32
Catalogue 46
Found Landscape with Remolino July 1993
mixed media on wood
Collection of Robert L. B. Tobin, San Antonio

Plate 33
Catalogue 48
Death of Innocence May 16, 1994
acrylic and charcoal on canvas
Collection of the El Paso Museum of Art,
Robert U. and Mabel O. Lipscomb Foundation Endowment Purchase

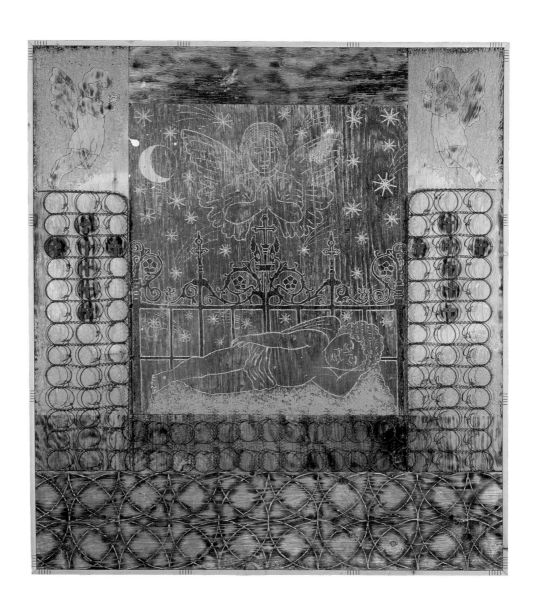

Plate 34
Catalogue 49
Soñando con los Angelitos November 14, 1994
mixed media on wood
Courtesy of the artist

77

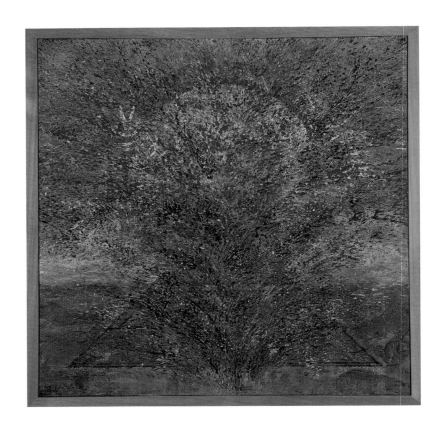

Plate 35
Catalogue 50
El Tiempo Borra Todo I June 11-17, 1998
mixed media on canvas
one of a series of 4
Courtesy of the artist

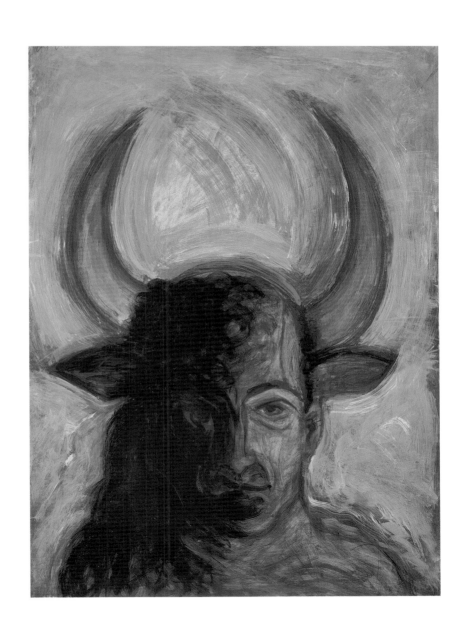

Plate 36
Catalogue 52
Europa August 24, 1989
acrylic on paper
Collection of Lewis Dickson, Esq., Houston

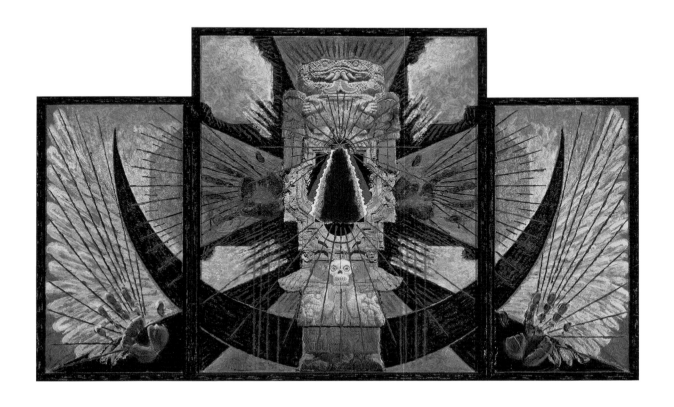

Plate 37
Catalogue 54
Reinvented Icon for this Time and Place (San Antonio)
June 3, 1991
mixed media on masonite
Courtesy of the artist

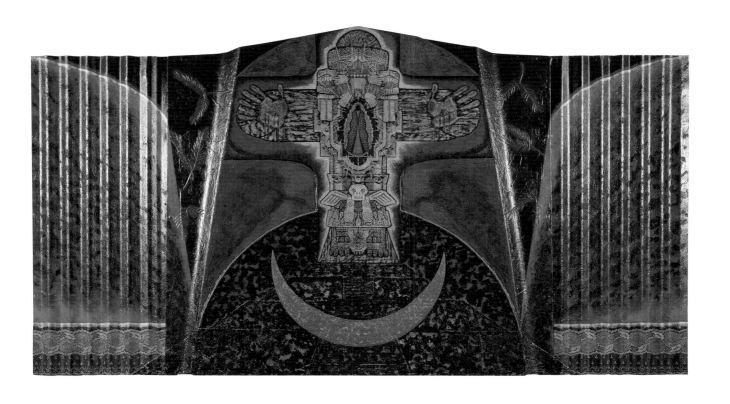

Plate 38
Catalogue 55
Quinto Sol: Cruz Mestiza June 30, 1992
mixed media on car hood and corrugated metal
Collection of Nancy and Charles Kaffie, Corpus Christi

81

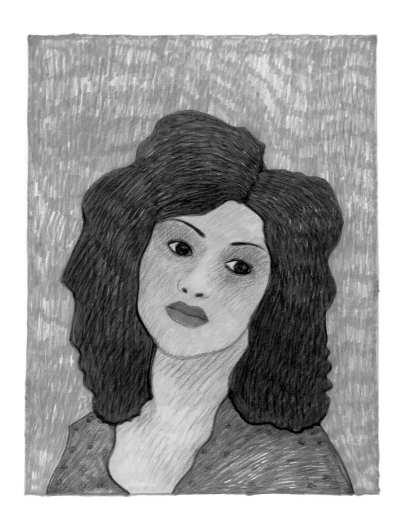

Plate 39
Catalogue 56
Mujer in 1950s Pose May 1, 1980
mixed media on paper
Collection of Joe A. Diaz, San Antonio

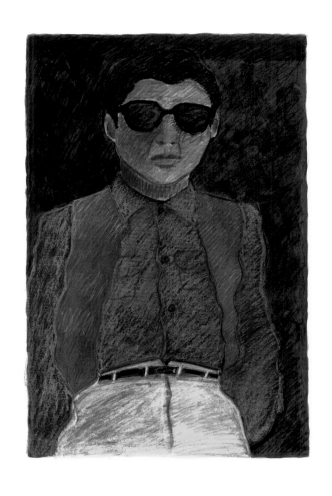

Plate 40
Catalogue 58
Bato con Khakis April 8, 1982
watercolor and crayon on paper
Collection of Joe A. Diaz, San Antonio

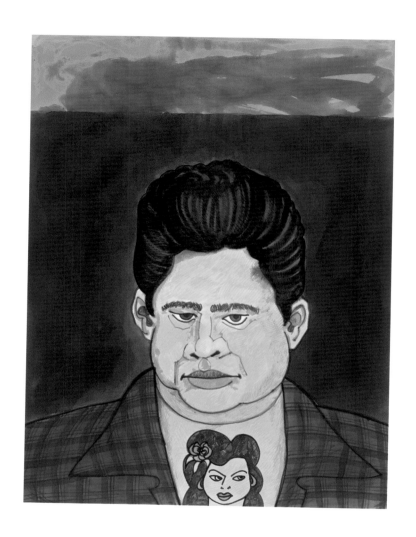

Plate 41
Catalogue 60
A Man and His Dreamgirl October 1, 1990
mixed media on paper
Collection of Joe A. Diaz, San Antonio

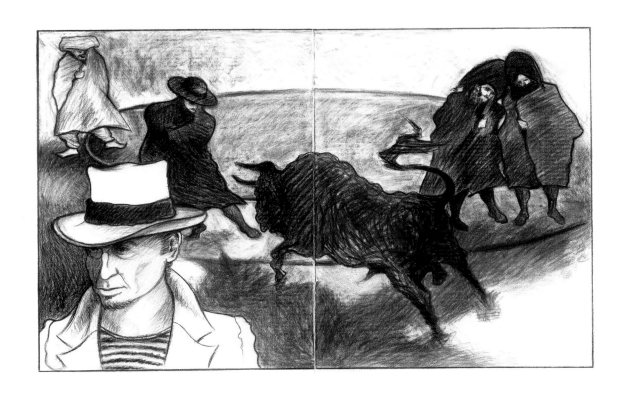

Plate 42
Catalogue 64
Shadowy Figures (After Goya) December 11, 1986
charcoal on paper
Collection of the artist

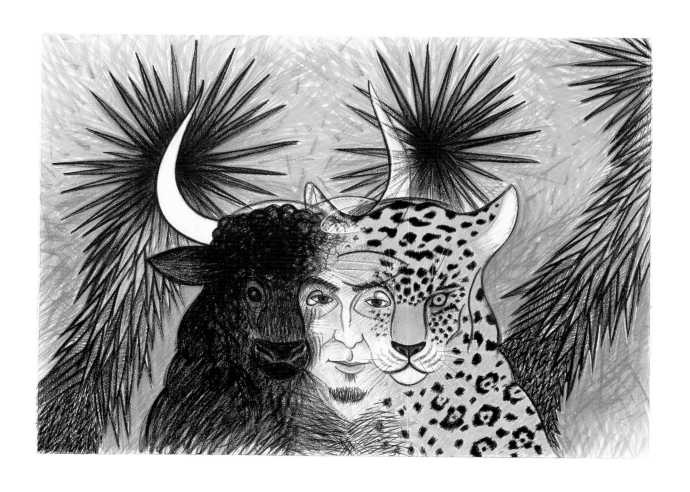

Plate 43
Catalogue 66
El Mestizo June 11, 1987
charcoal and pastel on paper
Courtesy of the artist

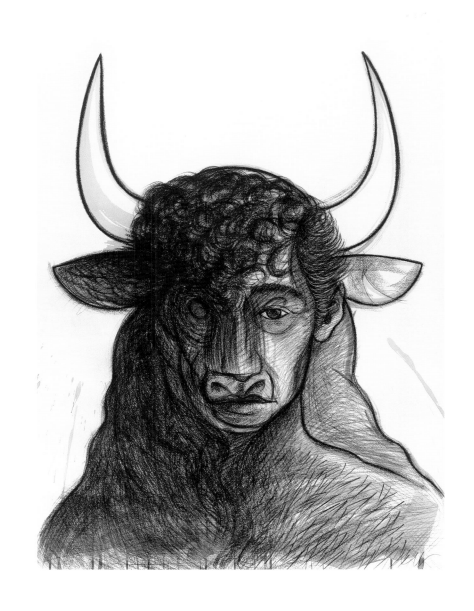

Plate 44
Catalogue 68
Europa October 6, 1990
charcoal and watercolor on paper
Courtesy of the artist

Plate 45
Catalogue 73
Liberación 1975
woodcut
Courtesy of the artist

Plate 46
Catalogue 74
Peyotl 1976
hand-colored woodcut
Courtesy of the artist

89

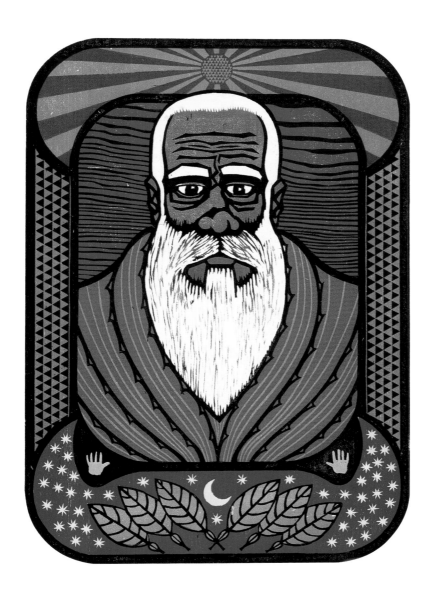

Plate 47
Catalogue 76
Don Pedrito Jaramillo 1976
woodcut
Courtesy of the artist

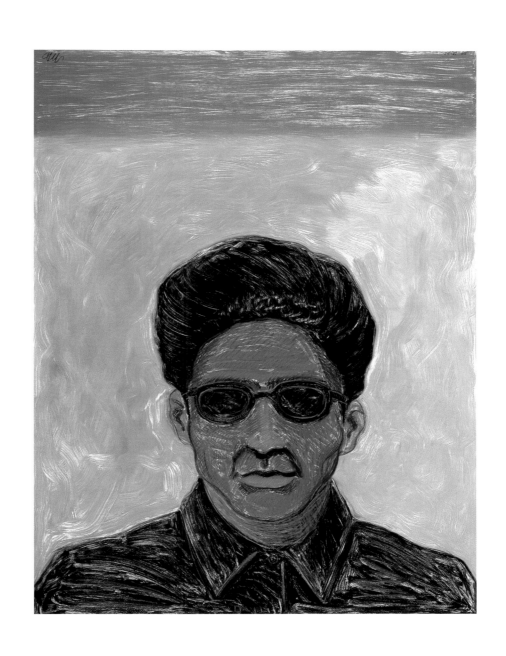

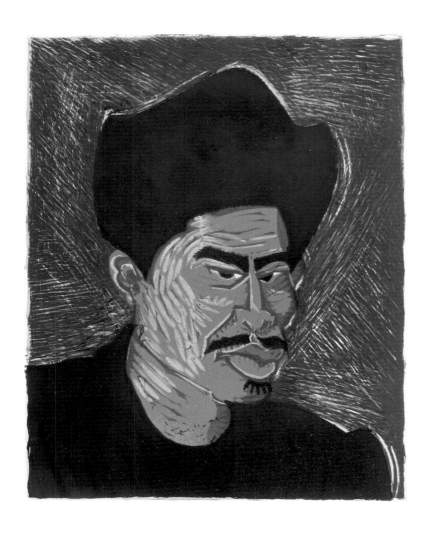

Plate 49
Catalogue 80
Bato Rojo November 7, 1988
linocut
Collection of Joe A. Diaz, San Antonio

Plate 50
Catalogue 81
Calavera Torera September 18, 1990
linocut with watercolor on paper
Courtesy of the artist

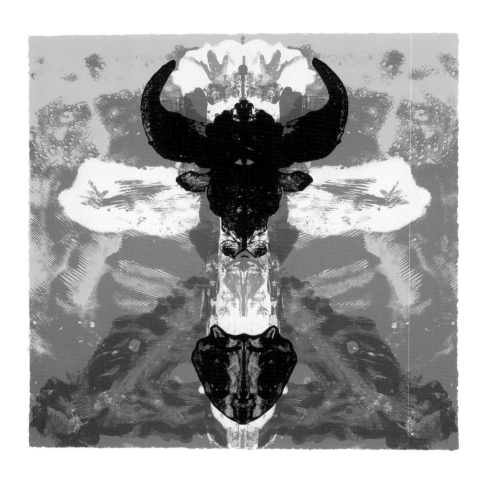

Plate 51
Catalogue 84
Pirámide con Cruz y Toro #2 July 25, 1995
screenprint
Collection of Joe A. Diaz, San Antonio

Plate 52
Catalogue 86
ArtPace 97.3 Monotype #15 May-July 1997
monotype
Collection of Pat and Bud Smothers, San Antonio

Plate 53
Catalogue 88
ArtPace 97.3 Nike de San Anto Monotype #3 August 1997
monotype
Courtesy of the artist

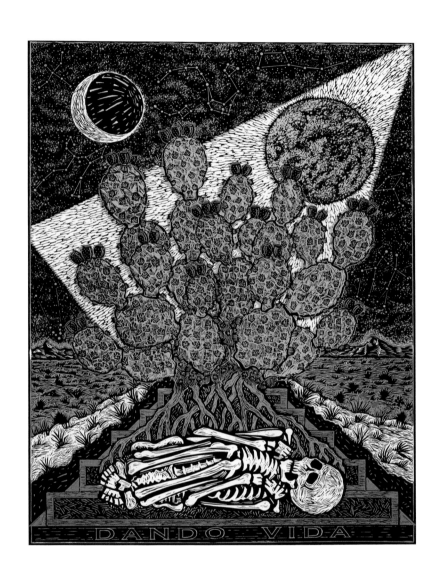

Plate 54
Catalogue 89
Dando Vida 1999
linocut and lithograph
Courtesy of Hare and Hound Press, San Antonio

CHRONOLOGY

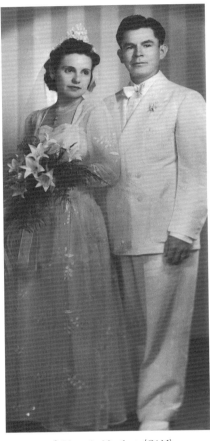

Parents of César A. Martínez [CAM] on their wedding day, 1943.

CAM's maternal grandmother, Laredo, circa 1950s.

CAM, 5 years old, on his first day of school, Laredo, Texas. Photographed by his aunt, Lydia.

CAM with his mother in Laredo, 1945.

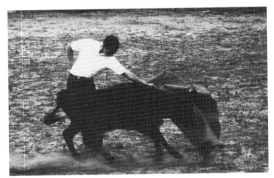

CAM training, Cuco Peña Ranch, Tamaulipas, Mexico in the mid-1960s.

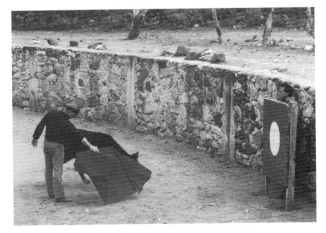

CAM, Ajacuba, Mexico, 1997.

1930 Cruz Garza de Garza, grandmother, emigrates to Laredo, Texas from the family ranch in the state of Nuevo León in northern Mexico bringing all of her children except the oldest son.

1943 Parents, Adela Garza Garza and Mariano Santa Anna Martínez, both Mexican immigrants, marry in Laredo, Texas.

1944 César Augusto Martínez [CAM] is born in Laredo, Texas on June 4th.

1945 Father dies on March 4th. Mother moves in with her mother, Cruz; sisters, Concepción and Lydia; and brother, Juan Manuel Garza respectively.

1949 CAM is hospitalized and nearly dies of peritonitis as a result of acute appendicitis.

1950-56 Attends Buenos Aires Elementary School through sixth grade. An interest in the arts is recognized and encouraged by teachers and family. Often excused from regular school classes to work on art or theater set projects.

1956-59 Enters Lamar Junior High School and during the 9th grade begins art classes with Mrs. Quiroz. Under her direction, participates in the creation of a prize-winning Washington's birthday parade float.

1959 A lifelong fascination with the art of bullfighting takes hold after his mother buys him a book about the legendary *matador*, "Manolete."

1959-62 Attends Martin High School. Becomes a regular at *corridas de toros* in the old *plaza de toros* in Nuevo Laredo.

1962 Graduates from Martin High School, Laredo, Texas.

1962-64 Attends Laredo Junior College with focus on Business Administration. Develops an interest in becoming a professional *torero* and starts training with *novilleros* and other professionals in Nuevo Laredo and facing real fighting animals in Mexican bull-breeding ranches. Pursues painting on his own, often copying bullfight posters of the period.

1964-68 Attends Texas A & I University, Kingsville, Texas. After a dismal first semester of Business Administration courses, changes major to All Level Art Education. Fellow classmates include future Chicano movement artists George Truan, Carmen Lomas Garza, Amado Maurilo Peña, Jr. and José Luis Rivera.

Interest in bull fighting continues, often driving home on weekends to attend *corridas* in Nuevo Laredo and to keep in touch with bull fighter friends.

Meets lifelong friend, then a Chicano campus activist, Carlos Guerra, and through him develops an interest in the emerging Chicano political movement.

1966 Attends summer session at North Texas State University, Denton, Texas.

1968 Graduates from Texas A & I University with a Bachelor of Science degree in All Level Art Education, becomes eligible for Vietnam era military draft with end of educational draft deferment.

1969 Drafted into the U.S. Army on the eve of first one-person exhibition at the Texas A&I University Art Gallery. Never gets to see his own exhibition.

Receives basic training at Fort Bliss, El Paso, Texas.

Receives advanced training as a radio operator at Fort Ord, California.

1970 Spends last 14 months of military service as a radio operator at 7th Medical Battalion in Camp Casey, Republic of South Korea. Travels on military leave to Japan and buys first Nikon cameras and satisfies creative urges by immersing himself in photography. Receives award in photography contest.

1971-74 Receives Honorable Discharge from active duty in March, 1971.

Moves to San Antonio, Texas after making contact with Carlos Guerra and other Chicano activist friends. Starts working as head of the cultural component of the Texas Institute for Educational Development (TIED), of which Carlos Guerra is the Executive Director. TIED was a non-profit community services organization.

1971-74 Becomes associated with Chicano artists' groups in San Antonio and meets West side artists Jesús María "Chista" Cantú, Felipe Reyes, José Esquivel, Roberto Ríos, Jesse Almazán, Santos Martínez, Jesse Treviño, Rudy "Diamond" García, José Garza, David González, and Mario Lozano.

Freelances as a photographer. With National Endowment for the Arts and other foundation funding, organizes "Chicano Art of the Southwest," an art documentation project.

Meets Jacinto Quirarte, then teaching at the University of Texas at Austin and putting the finishing touches on his book *Mexican American Artists*, the first major book to acknowledge Chicano Art.

Meets artist Mel Casas.

1974 Joins *Con Safos* Chicano Art Group. Shortly thereafter, leaves with Carmen Lomas Garza and Amado Maurilo Peña, Jr. to start a new group called *Los Quemados*.

Becomes associated, as a photographer and occasional writer, with *CARACOL*, a monthly Chicano journal published by TIED and edited by close friend, Cecilo García-Camarillo.

1975 Meets Jim Harithas, Director of the Contemporary Art Museum in Houston, who visits San Antonio pursuing the possibility of having an exhibition of Chicano Art. In 1977, *Dále Gas*, curated by Santos Martínez, opens in August at the Museum.

1975 Meets Marc Zuver and Rebecca Kelly Crumlish from Fondo del Sol Visual Arts and Media Center, Washington, D.C., who are traveling the Southwest pursuing the possibility of putting together a national touring survey exhibition of art by Latin American artists from the United States. Two years later, this exhibition becomes a reality with opening of *Ancient Roots/New Visions*, the first major survey of its kind in the United States, which opens in Tucson, Arizona.

1976 Exhibits work in *Tejano Artists*, first exhibition of art by Chicano artists to tour in Texas.

1978 After years of consideration, begins *Bato* and *Pachuco Series*.

1983 Appears in first of three major nationally aired documentaries on PBS dealing with Chicano and Latino Art.

Meets curator and fellow artist, Benito Huerta.

1984 Awarded top cash prize for best of show in *¡Mira! The Canadian Club Hispanic Art Tour*, 1984, at the Museo del Barrio, New York City.

1986 Begins *Mestizo Series*.

1989 Begins *South Texas Series*.

1992 Starts long-standing collaboration with master printer Peter Webb of Strike Editions, Austin, Texas.

1996 Dormant but not forgotten interest in *los toros* is revived by acquaintances in Mexico, satisfying long-standing obsession to work, if only for own pleasure, with pure-bred fighting stock once more at Mexican bull-breeding ranches.

1997 Selected by Suzanne Ghez as the San Antonio artist to participate in *NEW WORKS: 97.3*, the third residency of the ArtPace International Artist-in-Residence 1997 Program.

1998 Receives invitation to be a Visiting Artist at the University of Texas at San Antonio, Spring 1999.

Lenders to the Exhibition

Pablo Alvarado, Dallas

Bruno Andrade, Corpus Christi

Bromley Aguilar + Associates, San Antonio

Mary Ann Smothers Bruni, San Antonio

Alfredo Cisneros, Elburn, Illinois

Janie and Dick DeGuerin, Houston

Joe A. Diaz, San Antonio

Lewis Dickson, Esq., Houston

Carlos Guerra, San Antonio

Hare and Hound Press, San Antonio

Ann and James Harithas, Houston

Nancy and Charles Kaffie, Corpus Christi

Bernard Lifshutz, San Antonio

Cheech Marin, Los Angeles

Adela G. Martínez, Laredo

César A. Martínez, San Antonio

María Elena Martínez, Austin

MD MODERN, Houston

Emma L. Mendiola, San Antonio

Guillermo Nicolas, San Antonio

El Paso Museum of Art, El Paso

Parchman/Stremmel Gallery, San Antonio

San Antonio Museum of Art, San Antonio

Michele and Alan Skupp, Livingston, New Jersey

Pat and Bud Smothers, San Antonio

Robert L. B. Tobin, San Antonio

Maria and Roberto Treviño, San Antonio

OTHER PUBLIC AND PRIVATE COLLECTIONS

Art Museum of South Texas, Corpus Christi

Center for the Arts, Vero Beach, Florida

Colegio de la Frontera, Tijuana, Baja California, Mexico

Federal Reserve Bank of Dallas, Dallas

Fondo del Sol Visual Arts and Media Center, Washington, D.C.

Mexican Fine Arts Center Museum, Chicago

Museum of Fine Arts, Houston, Houston

Museo Nacional de la Estampa, Mexico D.F., Mexico

Museum of Texas Tech University Association, Lubbock

SBC Communications, San Antonio

University of Texas at San Antonio, San Antonio

Bob and Gracie Cavnar, Houston

Elizabeth and William Chiego, San Antonio

Frederick Creech, Monroe, North Carolina

Sandra Cisneros, San Antonio

Alison de Lima Greene, Houston

Janet and Glenn Douglas, Houston

Sam and Canda Fadduol, Lubbock

Lynne Goode and Tim Crowley, Houston

Sandra and Rafael Guerra, San Antonio

Benito Huerta, Arlington

Neel and Allison Hays Lane, San Antonio

Hilda and Michael Lathrop, Corpus Christi

Virginia Lebermann, Austin

Dr. and Mrs. Larry Lopez, San Antonio

Ralph Méndez, San Antonio

Mary and Tyler Moore, Bryan

Mr. and Mrs. Henry R. Muñoz III, San Antonio

Lisa Ortíz, San Antonio

Linda Pace, San Antonio

Carolyn and John Seale, San Antonio

Marie and Pic Swartz, San Antonio

Robert St. John, Houston

Michael Wasserman, Houston

Francisco J. Velásquez, San Antonio

SELECTED EXHIBITIONS

One-person Exhibitions

1978 *New Paintings*, Xochil Art Center Gallery,
Mission, Texas

1980 Dagen-Bela Galería, San Antonio

1987 Galería Sin Fronteras, Austin

1988 *There is a Chicano in There Somewhere*,
Guadalupe Cultural Arts Center,
San Antonio

1988 Galería Sin Fronteras, Austin

1990 *César A. Martínez: Mixed Media Paintings*,
San Angelo Museum of Fine Art,
San Angelo, Texas

1990 *César A. Martínez Exhibition*,
MARS (Movimiento Artístico
del Río Salado), Phoenix

1991 *César A. Martínez: Three Major Series*,
Texas A & I University, Kingsville

1992 Galería Sin Fronteras, Austin

1993 *César Martínez: Recent Work*,
Lynn Goode Gallery, Houston

1994 *César Martínez: Recent Works
from Lynn Goode Gallery*,
Texas Medical Center, Houston

1995 *César Martínez: Reflejos Mestizos/Focus Series*,
El Paso Museum of Art, El Paso

1996 *4+4+4+4*, Lynn Goode Gallery, Houston

1997 *New Works: 97.3*, ArtPace International
Artist-in-Residence Program, ArtPace A
Foundation for Contemporary Art, San Antonio

1998 *César A. Martínez: Cultura De South Texas*,
Art Museum of South Texas, Corpus Christi

1999 *César A. Martínez: Artist of the Year*,
San Antonio Art League Museum, San Antonio

Group Exhibitions

1977 *Dále Gas*, Contemporary Arts Museum, Houston

1979 *Fire, One-hundred Texas Artists*, Contemporary
Art Museum, Houston

1981 *Quinta Bienal Del Grabado Latino Americano*,
Instituto de Cultura Puertorriqueña,
San Juan, Puerto Rico

1983 *Tejano*, Fondo del Sol Visual Arts and Media
Center, Washington, D.C.

Showdown, Part II, The Alternative Museum,
New York

1986 *Chicano Expressions*, INTAR Latin American
Art Gallery, New York,

1987 *Influence, Part II*, San Antonio Museum of Art,
San Antonio

1990 *15 Pintores y 3 Escultores Tejanos: Artistas
Mexicano – Norteamericanos*, Museo de Alvar
y Carmen T. De Carillo-Gill, Mexico, D.F., Mexico

1991 *A Sense of Place: Recent Acquisitions in
Contemporary Texas Art*, San Antonio
Museum of Art, San Antonio

Target: South Texas/The World Outside,
Art Museum of South Texas,
Corpus Christi

1992 *New Texas Art: 20 Contemporary Texas Artists*,
Cheney Cowles Museum, Spokane, Washington

*Encounter: A Commemoration of Five Hundred
Years of Fusion of Cultures*, Jansen-Pérez
Gallery, Los Angeles

1993 *Sin Frontera: Chicano Art from the Border States of the United States*, Greater Manchester Arts Centre Limited, Manchester, England

Texas Contemporary: Acquisitions of the 90s, The Museum of Fine Arts, Houston, Houston

1996 *Texas Modern and Post-Modern,* The Museum of Fine Arts, Houston, Houston

1997 *New Works: 97.3*, ArtPace, San Antonio

Finders Keepers, Museum of Contemporary Art, Houston

Tres Proyectos Latinos, Austin Museum of Art at Laguna Gloria, Austin

1998 *Collective Visions*, San Antonio Museum of Art, San Antonio

Selected National Touring Exhibitions

1976 *Tejano Artists: An Exhibition of Mexican-American Art*

Venues:

Electric Tower Display Gallery, Houston

Institute of Texan Cultures, San Antonio

La Lomita Museum of Fine Art, Mission

First Federal Display Plaza, Austin

1977 *Ancient Roots/New Visions*

Venues:

Tucson Museum of Art, Tucson

National Collection of Fine Art, Smithsonian Institution, Washington, D.C.

Albuquerque Museum, Albuquerque

El Paso Museum of Art, El Paso (1978)

Los Angeles Municipal Art Gallery, Los Angeles (1978)

Blaffer Gallery, University of Houston, Houston (1978)

Colorado Springs Fine Arts Center, Colorado Springs (1978)

Everson Museum of Art, Syracuse (1979)

Witte Museum, San Antonio (1979)

Museum of Contemporary Art, Chicago (1979)

Palacio de Minería, Mexico, D.F., Mexico (1980)

1984 *¡Mira!: The Canadian Club Hispanic Art Tour*

Venues:

Museo del Barrio, New York

San Antonio Museum of Art, San Antonio

Plaza de la Raza, Los Angeles

1986 *¡Mira!: The Tradition Continues*

Venues:

The Museo del Barrio, New York

The Hyde Park Art Center, Chicago

The Cuban Museum of Art and Culture, Miami

Cullen Center, Houston

Arvada Center, Denver (1987)

Plaza de la Raza, Los Angeles (1987)

Chulas Fronteras

Venues:

Bath House Cultural Arts Center, Dallas

Midtown Art Center, Houston

Cultural Activities Center, Temple, Texas

Texas Cultural Symposium Art Space, San Antonio

Corpus Christi State University, Corpus Christi

American Museum, El Paso (1987)

McAllen International Museum, McAllen, Texas (1987)

1987 *Hispanic Art in the United States:*
 Thirty Contemporary Painters and Sculptors

 Venues:

 The Museum of Fine Arts, Houston, Houston

 The Corcoran Gallery of Art,
 Washington, D.C. (1988)

 Lowe Art Museum, Miami (1988)

 Museum of Fine Art and Museum of Folk Art,
 Santa Fe (1988)

 Los Angeles County Museum of Art,
 Los Angeles (1989)

 The Brooklyn Museum, Brooklyn (1989)

1990 *Chicano Art: Resistance and Affirmation,*
 1965-1985

 Venues:

 The Wight Gallery, University of California
 at Los Angeles

 The Denver Art Museum, Denver (1991)

 The Albuquerque Museum,
 Albuquerque (1991)

 San Francisco Museum of Art,
 San Francisco (1991)

 Fresno Art Museum, Fresno (1991)

 Tucson Museum of Art, Tucson (1992)

 National Museum of American Art,
 Washington, D.C. (1992)

 El Paso Museum of Art, El Paso (1992)

 The Bronx Museum, New York (1993)

 San Antonio Museum of Art,
 San Antonio (1993)

1993 *Art of the Other Mexico: Sources and Meaning*

 Venues:

 Mexican Fine Arts Center Museum, Chicago

 Museo de Arte Moderno, Mexico, D.F., Mexico

Museo Regional de Santo Domingo,
Oaxaca, Mexico (1994)

Centro Cultural Tijuana,
Tijuana, Baja California, Mexico (1994)

Palm Springs Desert Museum,
Palm Springs (1994)

Museo del Barrio, New York (1995)

Yerba Buena Cultural Center,
San Francisco (1995)

La Frontera/The Border:
Art About the Mexican/U.S. Border Experience

Venues:

Centro Cultural Tijuana, Baja California, Mexico

Tacoma Art Museum, Tacoma

Scottsdale Center for the Arts, Scottsdale (1994)

Neuberger Museum, State University
of New York at Purchase (1994)

San Jose Museum of Art, San Jose (1994)

1994 *Ceremony of Spirit: Nature and Memory*
 in Contemporary Latino Art

 Venues:

 The Mexican Museum, San Francisco

 Austin Museum of Art at Laguna Gloria,
 Austin (1995)

 Huino'eah Visual Arts Center,
 Makawao, Hawaii (1995)

 Fullerton Art Center, Fullerton, California (1996)

 Boise Art Museum, Boise (1996)

 Studio Museum of Harlem, New York (1996)

 Fresno Metropolitan Museum, Fresno (1996)

SELECTED BIBLIOGRAPHY

Books

American Images: The SBC Collection of Twentieth-Century American Art. New York: SBC Communications, Inc., 1996. Harry N. Abrams, plate 138; Jacinto Quirarte, "Ethnicity, Outsiderness, New Regionalism."

Goldman, Shifra M. *Dimensions of the Americas: Art and Social Change in Latin America and the United States*. Chicago: University of Chicago Press, 1994.

Johnson, Patricia Covo. *Contemporary Art in Texas*. Australia: G & B Arts International, 1995.

Lippard, Lucy R. *Mixed Blessings: New Art in a Multi-cultural America*. New York: Pantheon Books, 1990, plate 25.

Quirarte, Jacinto. Sources of Chicano Art: Our Lady of Guadalupe. *Journal of the National Association for Ethnic Studies*. "Explorations in Ethnic Studies: Ethnicity and the Arts." Editor: Gretchen M. Bataille, January 1992, Vol. 15, No. 1.

Quirarte, Jacinto. *A History and Appreciation of Chicano Art*. Research Center for the Arts and Humanities, San Antonio, 1984.

Quirarte, Jacinto. Art. *The Hispanic-American Almanac*. Detroit: Gale Research, Inc., 1993.

Shorris, Earl. *Latinos: A Bibliography of the People*. New York: W.W. Norton and Co., 1992.

Periodicals

Anspon, Catherine D. "From South Africa, South Texas, Herman and Martínez Shows, Two Enthrall." *Public News*, June 19, 1996, Art Section, p. 12.

Bernstein, Ellen. "The Color of Culture." *Corpus Christi Caller-Times*, October 4, 1998, pp. 1H, 3H.

Crossley, Mimi. "Dále Gas at the Contemporary Arts Museum." *Art in America*, January - February 1978, pp.119-120.

Ennis, Michael. "Moving Pictures." *Texas Monthly*, July 1993, pp. 52-57.

Frohman, Mark. "César Martínez/Marilyn Lanfear at Lynn Goode Gallery." *Art News*, October 1993, p. 172.

Goddard, Dan R. "Igual Pero Diferente." *Latin American Art*, Summer 1992, Volume 4, Number 6, pp. 75-76.

Goddard, Dan R. "Blending Cultures." *San Antonio Express-News*, November 18, 1998, pp. 1G, 12G.

Guerra, Carlos. "The Dangerous Life and Quiet Art of César Martínez." *Commercial Recorder*, April 19, 1990, pp. 1, 23-24.

Huerta, Benito. "César Martínez." *Artlies*, Winter 1997-1998, Number 17, p. 45.

Johnson, Patricia C. "Texas Artists Inspired by Forms from Folk Religion." *Houston Chronicle*, September 10, 1990, Zest Section, p. 10.

King, Ben Tavera. "Martinez's Art Has South Texas Focus." *San Antonio Express-News*, April 7, 1991, Section H, pp. 1, 7.

Kutner, Janet. "Texas Talent in New York." *The Dallas Morning News*, May 27, 1983, Section C, pp. 1, 3.

McCombie, Mel. "Surveying the Range." *Artweek*, June 1987, Volume 18, Number 22, p. 9.

Mitchell, Charles Dee. "Fronteras Gracefully Crosses Artistic Borders." *Dallas Observer*, June 19, 1986.

Moser, Charlotte. "Barrio to Museum." *Houston Chronicle*, August, 21, 1977, p. 15.

Quirarte, Jacinto. *¡Mira!: The Canadian Club Hispanic Art Tour*. Detroit, 1984, p. 6.

Quirarte, Jacinto. "César Augusto Martínez: Reflejos Mestizos." *Focus*, El Paso Museum of Art, 1995, pp. 1-2.

Raynor, Vivien. "¡Mira! Exhibition at Museo del Barrio." *The New York Times*, January 4, 1986, Arts Section, p. 1.

Richard, Paul. "From Pachucos to Vaqueros." *The Washington Post*, April 15, 1983, Section C, pp. 1, 6.

Sheffield, Susana. "Chulas Fronteras." *ArtScene*, Fall 1986, Volume 7, Number 14, pp. 14-15.

Sorrell, Victor Alejandro. "Citings from a Brave New World." *New Art Examiner*, May 1994, pp. 28-32, 56-57.

GLOSSARY

Beto la Momia – literally, Beto the Mummy. Apparently Beto (short for Alberto, and sometimes Roberto) looked like a mummy to someone, and it stuck as a nickname.

banderilla – bullfight term for the colorful, paper-decorated darts placed at the junction of the bull's shoulders and neck by the banderilleros, the matador's helpers.

bato – Chicano slang for barrio youth.

carrilla – Barrio slang term for ribbing, kidding.

Con Safos – name of a Chicano artist group in San Antonio; Chicano slang for liberation or to free oneself.

Cono, El – nickname for a Texas A&I student named Rodolfo Sánchez; Spanish for "The Cone."

Dále Gas – title of a Chicano art exhibition held at the Contemporary Art Museum, Houston, Texas; Spanish and Chicano slang for "give it gas."

Dando Vida – title of work by César Martínez; Spanish for "giving life."

fulano (feminine)/fulana (masculine) – Unnamed individual, what's-his-name. Can also be a generic reference to a person in lieu of using that persons name, whether known or unknown.

Instituto Chicano de Artes y Artesanías – name of a Chicano cultural organization; Spanish for Chicano Institute of Arts and Crafts.

Los Four – Los Angeles-based Chicano artist group; Spanish for "the Four."

Los Quemados – name of San Antonio-based art group; Spanish for "the Burnt Ones."

Náhuatl – language of the Aztecs and other groups in Central Mexico.

novillero – Spanish for "novice."

pachuco – a term of unclear origin applied in the 1940s and 1950s to Mexican American youths in the urban Southwest, especially in the Los Angeles area.

Pintores de la Nueva Raza – Spanish for "Painters of the New People."

Platícame de carabinas – Spanish for "talk to me" about carbines or hunting.

Queso, El – nickname for a San Diego, California Chicano artist named Salvador Roberto Torres; Spanish for "cheese."

Tamales de venado – Spanish for venison tamales.

también – also, too, likewise.

Tlacuilo – Náhuatl for "writer or artist."

Zoot Suiter – a term used primarily by Anglos to describe a Chicano youth who affected a certain dress and lifestyle common in the 1940s. A Zoot Suiter usually wore baggy, pegged trousers, a long draped jacket heavily padded at the shoulders, a low crowned, wide-brimmed hat, and a long key chain.

Distributed by the University of Texas Press

© The Marion Koogler McNay Art Museum, 1999

All rights reserved.

ISBN: 0-916677-43-5

Library of Congress Catalog Card Number: 99-074078

Editors: Allison Hays Lane
 Marcia Goren Weser

Designer: DeLinda Stephens

Typesetter: Roslyn E. B. Walker

Photography: Thomas R. DuBrock, Houston

 Ron Randolf, Corpus Christi

 Joel Salcido, El Paso

 Michael Jay Smith, San Antonio

 Peggy Tenison, San Antonio

All images © César A. Martínez

Color Separation and Production: Command P

Printing: Clear Visions, Inc.